American Flower Painting

American Flower Painting

BY DENNIS R. ANDERSON

WATSON-GUPTILL PUBLICATIONS, NEW YORK

First published 1980 in New York by Watson-Guptill Publications,
a division of Billboard Publications, Inc.,
1515 Broadway, New York, N.Y. 10036

Library of Congress Cataloging in Publication Data
Anderson, Dennis R
 American flower painting.

 Bibliography: p.
 Includes index.
 1. Painting, American. 2. Flowers in art.
I. Title.
ND2301.A52 758′.42′0973 80-16235
ISBN 0-8230-0211-X

Manufactured in Japan

First Printing, 1980

Photo Credits: Plate 6, Robert Grove; Plates 7, 8, 11, 13, 29, Richard diLiberto; Plate 10, E. Irving Blomstrann; Plate 16, O.E. Nelson; Plate 21, William Titus; Plate 22, Brooks Johnson; Plate 26, Geoffrey Clements; Plate 27, John Tennant.

Edited by Lydia Chen
Designed by Jay Anning
Composed in 11 point Goudy Old Style

For my family—
Mom, Boyd, and Virgie
And my dear friends.

ACKNOWLEDGMENTS

Without the generosity and helpfulness of painting owners who have granted reproduction rights, this project would have been impossible. Their names are indicated or omitted as they directed. Special thanks go to Greta Meilman, Sotheby Parke Bernet, New York; Dr. Alvord L. Eiseman, San Francisco; Ira Glackens, Washington, D.C.; Miss Antoinette Kraushaar, Kraushaar Galleries, New York; Hilton Kramer, *The New York Times*; Linda Ferber, Brooklyn Museum, New York; Barbara Mathes, New York; Barbara Novak, Barnard College, New York; Lloyd Goodrich, Curator Emeritus, The Whitney Museum of American Art, New York; Georgia O'Keeffe, New Mexico; Warren Adelson, Coe Kerr Galleries, New York; John K. Howat, Doreen Bolger Burke, and David Kiehl, the Metropolitan Museum of Art, New York; John Wilmerding, Curator of American Art and Senior Curator, National Gallery of Art, Washington, D.C.; Ann Palumbo, Hillcrest Heights, Maryland; Bert Carpenter, Greensboro, North Carolina; Tom Styron, Curator of American Art, Chrysler Museum of Art, Norfolk, Virginia; Richard York, Hirschl and Adler Galleries, New York; Adelyn D. Breeskin, National Collection of Fine Arts, Washington, D.C.; Deirdre Wigmore, Kennedy Galleries, New York; and Robert Scholkopf, New York.

Dot Spencer and Lydia Chen, my editors at Watson-Guptill, have been particularly helpful in locating and obtaining reproductions, as well as giving valuable suggestions for the manuscript, and Jay Anning was indispensable as designer of this book. My friend Ron Pisano, Director of the Parrish Art Museum, Southampton, New York, I thank particularly for initiating Watson-Guptill's interest in the project.

Susan Harkavy, Mary Woods, Lawrence Casper, Mary Cash, and Graeme Bowler have been enormously helpful with research, typing, editing, locating documents, and clarifying ideas.

The staffs of the Frick Art Reference Library, Avery Art Library, Columbia University, and the New York Public Library have all been generous with their advice and help, both to myself and my assistants.

Finally and above all, my very special thanks to Sidney Bergen, Director of ACA Galleries, where "American Flower Paintings 1850–1950" was organized and exhibited in April 1978. Without his friendship, support, and advice this book would not exist.

Dennis R. Anderson

List of Plates

American Flower Painting

Flowers have played a rich and varied role as both subject and symbol throughout American painting. Besides the traditional still life, flowers have figured importantly as elements in portraits and landscapes, as pictorial reactions to scientific thought, archetypes for esthetic theory, oblique sexual statements, and abstract studies in light, color, and texture. Although American artists have continually been fascinated by the timeless yet evanescent beauty of the subject, few, if any, important American artists can strictly be called flower painters. Nevertheless, flowers are depicted in many of the finest American paintings.

Flowers not only preoccupied "trained" artists, but also the folk limners, who were unschooled, traveling illuminators. Their decorative and formal works often included flowers, and though their illuminations reflected current European styles of painting, the limners were important factors in the development of American folk art. In the catalogue to the Whitney Museum of American Art's 1974 exhibition of American Folk Art, the development of that style is called a "flowering" of native expression. This "flowering" was nurtured by periodic infusions of European tradition brought to America by immigrants, and reinforced by Americans steeped in the examples of European floral painting.

The earliest examples of flower painting in America occur not in fine art or folk art but in European botanical illustrations of the New World's flora and fauna. The French Huguenot Jacques le Moyne de Morgues (c.1533–1588) traveled to Florida in 1564 in an exploratory expedition. He produced watercolor documentaries of life in the region which included floral ornamentation. Although intended as scientific studies, the floral designs embellishing the borders of his watercolors reflected the influence of the French Baroque style which was current in his native country. English expeditions, like the French, included artists/illustrators in their companies. John White, an English artist, documented expeditions to the Outer Banks of North Carolina in 1584 and to Roanoke Island in the next year. In addition to illustrating Indians and their villages, White's maps included detailed studies of flowers.

Other early flower illustrations came from the hand of William Bartram (1739–1823), whose father John Bartram (1699–1777) corresponded with the famed Swedish botanist Carl Linnaeus (1707–1778) and was the first to cultivate botanical gardens in the New World. However, this early tradition of American flower painting was soon to be superseded by more important styles.

The flower painting tradition of the early Dutch settlers was to play the next decisive role in the American representation of flowers. The history of flower painting in Holland extends back to the development of the still life. Holland's independence from the Spanish Hapsburg Empire in the early 17th century together with the triumph of the Protestant Church—

which had prohibited the creation of "graven images"—destroyed the market for religious art. Landscapes, genre scenes, and still lifes—images drawn from everyday life—filled the artistic vacuum left by religious painting. Such interest in the "natural" had immediate appeal for the "haute bourgeoisie," who decorated their houses with landscapes and still lifes, symbols of their prosperity and success. These lush landscapes and still lifes provided welcome relief from the dreary Dutch weather. The popularity of still life in a country where the tulip formed the backbone of the economy is not surprising. The development of tulip hybrids had prompted wild economic speculation; when the market subsequently collapsed, many artists chose the tulip and its worthlessness as an appropriate symbol of *vanitas*.

Thus Dutch settlers brought to American art a fully developed experience and appreciation of flowers as the subject of paintings, and their influence was pervasive from the 1600s to the 1900s. Dutch settlers brought art with them, and like other commodities, bartered it from town to town. Large collections of Dutch art were formed in New York and Philadelphia—the principal ports of immigration for Dutch settlers. For Americans just beginning to collect art, the Dutch dealers were present to guide them. One such friendly dealer was a Dr. Weir, who offered Dutch still lifes and flower paintings.

Other collections of Dutch art came to America by Europeans who brought their already-acquired artworks with them. One important collector was Baron Stier, a Swiss visitor who brought his Dutch paintings to the United States in 1794. These paintings were exhibited in Maryland in 1816. Another one was the French connoisseur named Du Semetiere, who settled in Philadelphia with his extensive Dutch collection. Robert Gilmore was yet another important collector of Dutch art, owning more than 150 works. His paintings attributed to Rembrandt, Van Dyck, Vermeer, Hals, and Rubens were packed into every room. Besides his interest in European painting, Gilmore also encouraged the careers of young American artists.

The 17th-century Dutch style was also directly transmitted to America during the 19th century by Dutch artists who lived and worked in this country. Two such artists were Albert van Beest and F. H. de Haas, who were known to have been active in New York in the 1850s. Interest in Dutch still lifes peaked in this country late in the 19th century when the Metropolitan Museum of Art in New York and the Museum of Fine Arts in Boston were founded. The initial holdings of the Metropolitan Museum consisted primarily of Dutch and Flemish paintings, a collection of 174 works which generated much excitement at the time they were first exhibited.

After acquiring a taste for 17th-century Dutch paintings at home, American artists such as Martin J. Heade, Asher B. Durand, and Worthington Whittredge sought them out in European collections when they traveled abroad. These artists were very enthusiastic about the Louvre, which by 1830 boasted a major collection of such art.

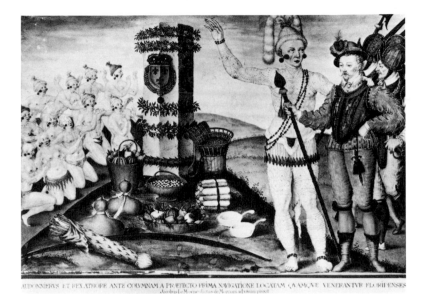

Jacques Le Moyne, René de Laudonniere with Chief Athore, 1564. *Original gouache painting, 7 × 10¼ in. (17.8 × 26 cm). Prints Division, The New York Public Library, Astor, Lenox and Tilden Foundations.*

Along with Dutch art, Spanish still lifes played an important part in the American artist's conception of flower painting. Seventeenth-century Spanish artists were exposed to the Baroque style through the work of contemporary Italians such as Caravaggio, and Flemish portrait painters like Van Dyck. Perhaps the first 17th-century Spaniard to feel the influence of Caravaggio was Juan Sanchez Cotan. Cotan's remarkable still lifes contained an order and simplicity dramatically different from the lavish Netherlandish display of food and flowers. His surreal and austere arrangements of still life elements influenced many American painters. The Spanish influence reached America via settlers during the colonial era and persisted into the 19th century, when American interest in Spanish art was awakened in a movement known as "Espagnolisme." American artists may have first seen Cotan's work and other Spanish Baroque paintings in an exhibition at the Pennsylvania Academy of the Fine Arts in Philadelphia in 1818.

The American settlers brought with them their respective native traditions, which, even when mingled, still retained the European complexion. These different influences all came to the New World: the French Baroque mode of flower embellishment, the English interest in the botanical classifications developed by Linnaeus, the lavish Dutch Baroque still life and portrait forms, and the austere Spanish Baroque style. However, with the English settlers' preference for the commemorative portrait, which be-

came popular due to strictures against religious representation, flowers alone did not become an important subject matter for painters until the 19th century. Then in the 1860s, largely due to the influence of the English Pre-Raphaelites, flower painting took its own direction in America.

The New England colonies were established as religious experiments to prove that man might live according to the Bible and prosper. The naive portrait tradition which developed often included flowers. It is possible that the colonial painter represented plucked flowers in his work as symbols of man's control over the natural world.

European artists had long used flowers in their portraits, and doubtless American painters who were familiar with the tradition adapted the practice to fit their own needs. To the European, accessories in the portrait had different meanings: a rock or column signified permanence, while a drape, landscape, or flower symbolized transience. The placing of objects within a portrait to identify the subject was a tradition borrowed from ancient and early Christian art, where, for instance, St. Jerome had his lion as attribute, and St. Catherine her wheel. However, while the Europeans employed the flowers most often as symbols illuminating the character of the sitter, the colonists may have in fact copied these symbols without an understanding of the history and complexity of the allegory. Roses and lilies, formerly the flowers of the Virgin, are repeatedly depicted with women in early American portraiture. Thus, while specific meanings are uncertain, the frequent association suggests the use of flowers as an allusion to femininity in general. In addition to decorating and adding meaning to colonial portraiture, flowers were used by itinerant painters to embellish carriages, milk tins, and other everyday objects.

Around 1725 American portraiture came under the influence of the English academic approach when a large number of trained English painters entered the colonies. These artists, students of Godfrey Kneller, were schooled in the English Baroque manner which held sway between 1715 and 1725. Kneller was one of a group of painters who were trained on the continent, mostly in Germany and Flanders, where flower paintings enjoyed a popularity equal to that of portraits. The group translated the aristocratic poses of Van Dyck, the 17th-century Flemish portrait master, into 18th-century terms. When these continental painters came to England, they established a cool, elegant portrait school which greatly influenced the native English style. In turn, this flowering Baroque style was transmitted to America. The earliest practitioner of this form of portraiture was Peter Pelham, who emigrated to Boston in 1726, soon to be followed by John Smibert and others.

This European influence flowed not only in the direction of English artists coming to America, but also from American artists going to England to study and work. London was a magnet which attracted such important artists as Boston portraitist John Single-ton Copley and Philadelphian Charles Willson Peale. For nearly twenty years (1755–1774) Copley's art was a synthesis of the native American tradition and European fine art. Copley's portraits of women done while he was still in America usually incorporated flowers in the costume or the background. On the eve of the Revolutionary War, Benjamin West, a fellow American artist already settled in London, urged Copley to join him there. Copley's departure left the field of American portraiture to be dominated by Charles Willson Peale, along with Gilbert Stuart and John Trumbull. Peale was the son of a well-born English tax collector who died when Charles Willson was still a child, and as a precocious adolescent he was sent to study with Benjamin West in London. After two years he returned to Philadelphia and served with distinction in the Revolutionary War under the same military and political leaders he was later to portray.

Portraits in the 18th century often commemorated special occasions, or served as remembrance of lost loved ones. A woman in pregnancy might have had her portrait painted to secure her place in the family should she not survive childbirth, and the lord and lady often had portraits executed as milestones in their lives. Peale used flowers in such paintings in order to reinforce specific meanings. For instance, he often depicted pregnant women holding sprigs of roses, the blossoms of which indicated the number of children in the family.

After the Revolutionary War, Peale established a museum which bore his name. Its main purpose was to place all of American nature in Linnaean order, which meant it was to be described and organized on the basis of internal structure rather than surface appearances. This museum project eventually involved all of Peale's children, who were each named after an Old Master: Rembrandt, Titian, Rubens, and Raphael. Perhaps because of the museum project, the Peale family consistently approached their paintings, and the world, with a scientific eye. For them, the study of science was a way of glorifying God's handiwork. Fruits and berries fresh from the vine with the blossoms still on them—symbols of thanksgiving, gratitude, and self-satisfaction—are the subjects for a number of their paintings and are always articulated in a realistic manner.

Although the early phase of American art was dominated by portraiture, no single subject matter prevailed in painting in the 1840s. Landscapes, still lifes, and portraits using flowers as symbolic adjuncts had great popularity and this genre was best expressed in the works by the Peales. For the Peales, as well as in general, the still life was a microcosm of the landscape—showing the nature of a much larger world by examining its smallest aspects.

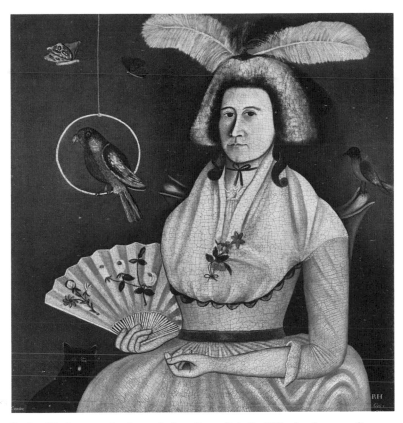

Rufus Hathaway, Lady with her Pets (Molly Whales Leonard),
*c. 1790. Oil on canvas, 34½ × 32 in. (87 × 81.3 cm). The
Metropolitan Museum of Art, Gift of Edgar William and Bernice
Chrysler Garbisch, 1963.*

*H*istorian William Gerdts points out in *American Still Life
Painting* that floral dictionaries, which explained the
symbolic meanings of flowers, appeared as an offshoot of
the popular literary annuals or gift books traditionally given at
Christmastime to a loved one or fiancée. Published in great
numbers beginning in the 1820s, floral dictionaries maintained
their popularity until the turn of the century. Following age-old
tradition, they ascribed specific feminine meanings to flowers: the
anemone represented frailty; the carnation represented pride; the
fuchsia, humble love; the heliotrope, devotion; the rosebud, con-
fession of love. In the Victorian era of repressed sensuality such
floral symbols communicated unspoken thoughts, feelings and
desires, and it is not surprising that painters used them in similar
ways.

Women artists played an important role in the art circles of
Victorian America. Since painting had become a socially accept-
able talent for women, hundreds of them painted and exhibited
floral works. Notable among these artists were Henrietta Maria

Benson Homer, whose son Winslow became a distinguished paint-
er himself; Julia McEntee; Ellen Robins; Amelia Henshaw; Mrs.
James M. Hart of the well-known Hart family of painters; Matilda
Browne; and Maria Oakey Dewing.

In this period the market for prints of flower images increased;
this market was created by women who wished to decorate their
parlors with flower pictures but could not afford paintings. Currier
and Ives, The Kellogs of Hartford, Pendleton, and other lithog-
raphers produced popular floral images. Although Currier and Ives
reproduced in prints the works of several of America's finest artists
of their time, most of the artists whose works were represented in
prints tended to be less significant or amateur.

Louis Prang was an important lithographer who included in his
chromolithographs flowers by women artists. The first Prang color
print was a simple bouquet of roses, inserted as an illustration in
The Ladies Companion for 1857. Later, flowers became the largest
and most important category of Prang prints. Mr. Prang's favorite
flower was the rose, which decorated his business card. After 1840
his hallmark became a rose blossom and bud with leaves and stem
above the letter "P." Prang's chromolithographs were sold not only
as prints but as greeting cards, trade cards, and mottos, and many
of the important flower painters of the time created Prang designs,
including Martin J. Heade, H.R. Neuman, Jean-Baptiste Robie,
Paul de Langpré, Fidelia Briggs, Theresa Hegg, and above all,
George C. Lambdin.

Lambdin perhaps can be called the first major American flow-
er painter. He created many such paintings, especially bouquets,
in the late 1850s and 1860s. The roses for his later works were
probably grown in his famous Germantown, Pennsylvania, gar-
den, as were many of the plants in his nature studies. His unprece-
dented magnification of the flower—remarkably foreshadowing
scientific studies—produced a simplification and concentration of
the image. Lambdin also experimented with color and texture to
imbue the flowers with an otherworldly luminosity, setting most of
them against dark backgrounds.

At mid-century, accessories to the still life—little birds, butter-
flies, fallen flowers, or petals—became important along with the
immediate surroundings of the bouquet. The use of a marble
tabletop as a solid support for the still life was introduced by
Dusseldorf artists like Severin Roesen. Roesen, a German painter
who came to America in the mid-1860s, established himself near
Williamsport, Pennsylvania. His luscious arrangements of flowers,
fruit, and other edibles continued the extravagant and overflow-
ing statements of the German Baroque. Meticulous attention to
each detail makes Roesen's flowers some of the most appetizing to
the eye.

*T*he uses of flowers increased in 1860, especially when
compared to the period before. Followers of every artistic
style in some way incorporated the flower: the Romantics,
the Symbolists, the Pre-Raphaelites, and many artists like the

Peales who made oblique references to science in their works, that is, artists having an "artistic/scientific eye."

The concept of Romanticism has embraced most, if not all, of American art history, and inherent in this concept are ideas and images which encompass the monumental, the mysterious, love of the land in both its pacific and hostile aspects, and most importantly the sublime. The idea of the sublime has in itself an interesting history and important implications for art. Edmund Burke's essay *Philosophical Enquiry into the Origin of our Ideas of the Sublime and the Beautiful* (1757) explored for the first time its many connotations. Early American painters ascribed to the concept of the sublime religious, moral, and ethical qualities. Later, the word came to mean imagination, fantasy, danger, mystery, and darkness. Thomas Cole, founder of the Hudson River School of landscape painting, expressed these romantic concepts by instilling in his fellow Americans a feeling for the epic qualities of the land.

The fantastic, which in literature pervades the work of Edgar Allan Poe, also fascinated such diverse artists as Albert Pinkham Ryder and Ralph Blakelock. Blakelock's rare flower paintings, like a few of George C. Lambdin's, express fantasy primarily through the use of a black background. For Blakelock as for Poe this absolute blackness is associated with the night, dreams, fear, love, and death, but it also provides a backdrop against which the brightly lit blossoms mysteriously glow in the moonlight.

Another mid–19th-century American who utilized flowers was James McNeill Whistler; for him the flower was an adjunct to the figure, both expressing notions of the sublime. Whistler's eventual obsessions with the nocturnal and Oriental were preceded by representations of the *The White Girl*, a series of paintings begun in 1861 that depict Whistler's mistress Jo Hefferman holding a flower. Although misunderstood by the critics and unappreciated by the public, *The White Girl* paintings presented Whistler with a formal problem that continued to fascinate him: the use of white as a color. Perhaps to better communicate this revolutionary notion, he eventually changed the title *The White Girl* to *Symphony in White No. 1*. His use of the flower in these paintings is related to both traditional and progressive portraiture. As seen in Charles Willson Peale's portraits, where the flower held by the sitter functions as a symbol of her fertility, the flower held by Jo Hefferman is an emblem of her sexuality.

Although Whistler was sympathetic to the aims of his Impressionist friends, his paintings such as *The White Girl* relate more closely to the Post-Impressionist/Symbolist Paul Gauguin. For the Symbolists, the reality of the inner idea of the dream could only be expressed metaphorically as a series of images from which the final resolution might emerge. The flower, one of the oldest symbols, was appropriated by the Symbolist movement. The wilted flower held by Whistler's *The White Girl* suggests sexual implications: the drooping petals, along with the tousled hair, crumpled dress, deep

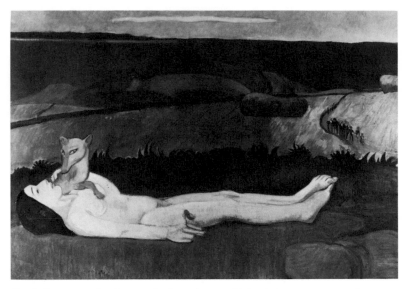

Paul Gauguin, La Perte du Pucelage, *1890. Oil on canvas, 35½ × 51¼ in. (90.2 × 130.2 cm). The Chrysler Museum, Norfolk, Virginia, Gift of Walter P. Chrysler, Jr.*

red lips, and vanquished-looking bearskin rug can be interpreted as metaphor for a recent ravaging, or perhaps a successful struggle against bestial urges. Although not as honestly titled as *La Perte du Pucelage* (the Loss of Innocence) by Gauguin, Whistler's *The White Girl* evidences strong similarities to the symbolist painting in its usage of the flower.

The English Pre-Raphaelites' meticulous representation of the details of nature appealed to mid–19th-century American painters. The "Pre-Raphaelite Brotherhood" had been founded in 1848 to restore "truth and beauty" to art through a revival of interest in paintings executed in the Renaissance before Raphael. Two years later, by 1850, the effects of this movement reached America through such publications as *The Crayon*, a journal of Pre-Raphaelite thought. But the most direct contact with the English movement came from a major exhibition of English watercolors and oils at the National Academy of Design in New York in 1857 and at the Boston Atheneum in 1858.

Davis Ramsay Hay, who in 1828 published *The Laws of Harmonius Coloring Adapted to Interior Decoration*, was an American precursor of the English Pre-Raphaelites. Like the Pre-Raphaelites, Hay maintained that shapes of nature should be the basis for decorative design. A similar position was taken by the Sommerly group around 1850. The group was founded in 1848 by Henry Cole, its purpose being to raise the tastes of the middle class by bringing together artists and manufacturers and creating a greater artistic awareness. The group proposed a new style in which nature should not be copied directly, but rather should be interpreted, transformed, and stylized. This position, supported by a number of

English writers and critics such as John Ruskin, coalesced in a movement known as the "Cult of Plant and Line."

American artists such as John William Hill were influenced by Ruskin's writings in the late 1850s. Hill's paintings of birds' nests and flowers exemplified the naturalist approach with their high-keyed colors, their chance arrangement, and an absence of contrived and grandiose compositions. Hill's interest in brilliant hues, found only in nature, anticipated the Impressionists' more formalistic preoccupation with light and color.

Scientific writings also had an effect on American artistic developments. The publication in 1852 of Alexander von Humboldt's *Personal Narrative of Travels to the Equinoctial Regions of America* fueled young artists' desires to travel and represent such exotic scenes as the Andes. Anticipating the American scientific age of the late 1860s and '70s, painters like Frederick Church employed a realistic approach in their representations of nature when they traveled in search of its drama.

The growing interest in science and the application of scientific method to art can be seen in the works of John La Farge. In the 1860s La Farge began to investigate problems of light that predated similar Impressionist studies by about thirty years. By experimenting with glass of varying thickness, opalescence, and other qualities, La Farge found that he could produce painterly effects equal to those of Gothic stained glass, which he had seen in European cathedrals. The success of these experiments is evident in the unusual richness and subtlety of his palette. La Farge's representations of flowers, which include waterlilies, magnolias, and roses, also show the effects of the Pre-Raphaelites' nature studies, Gothic and Romanesque floral ornaments, and Japanese textile designs, the latter probably seen during a trip to Japan in 1886. His *Flowers on a Window Ledge* is an example of his fascination with the interplay of interior and exterior light upon flowers, as well as with the contrast between the natural forms and the angular, "manufactured" windowsill.

The origins of Art Nouveau's flowers and tendrils can be traced in England to Ruskin and the Sommerly group's interest in ornamental forms derived from nature. Later on, around 1870, Walter Crane, Theodore Dresser, and Alfred Mackmurdo would carry the Proto–Art Nouveau movement further with the use of floral designs in book illustrations, wallpapers, and textiles. Dresser's knowledge of flowers came from his studies as a botanist; Mackmurdo studied floral details and interlacing tendrils in Gothic and Romanesque architectural decoration. He supported this historical knowledge with naturalistic studies of plants. It is surely not coincidental that this artistic interest in plants followed the publication of Darwin's *Origin of Species* in 1859 and his later botanical studies (*Fertilization of Orchids*, *Cross and Self-fertilization of Plants*, *Forms of Flowers*, and *The Movement of Plants*). Darwin's

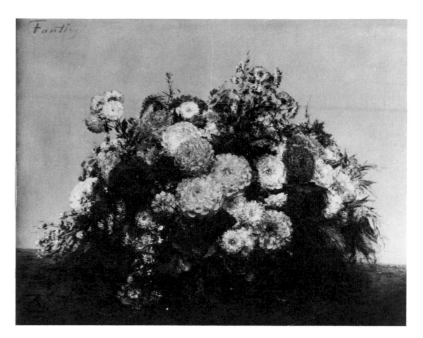

Ignace Henri Jean Théodore Fantin-Latour, Gros Vase de Dahlias et Fleurs Variées, *c. 1875. Oil on canvas, 19¾ × 25 in. (50.2 × 63.5 cm). The Chrysler Museum, Norfolk, Virginia, On Loan from Collection of Walter P. Chrysler, Jr.*

innovative approach was applied not only to primate development, but also to plants and flowers. His ideas were disseminated in America by Asa Gray and others, and were the subjects of debate in American academic and intellectual circles.

Like their English counterparts, American artists were influenced by scientific thinking; their floral subjects were often the same objects that scientists were investigating. The American artist who best exemplified this interface of art and science, an artist having the "artistic/scientific eye," was Martin J. Heade. During a visit to London in 1864, Heade probably saw recent works by Henri Fantin-Latour, a 19th-century French flower painter whose crisply detailed depictions would affect Heade's own floral representations. While in England, he may also have become acquainted with the most recent scientific thought on flowers in Darwin's publications. Like a scientist collecting data, Heade made three trips to Brazil between 1863 and 1870 in order to study the hummingbirds and orchids which became his subjects in 1871. The famous paintings that resulted distilled Darwin's findings and depicted with an almost biological accuracy not only the exotic appearance of the orchids but also the mating habits of the hummingbirds.

Heade's compositions are complex amalgams of the traditional still life genre, the epic landscape, new scientific attitudes toward nature, and formal manipulations of light, color, and texture. It is evident when such a variety of interpretations can be applied to a single group of paintings that these works are among the most sophisticated of the 19th century.

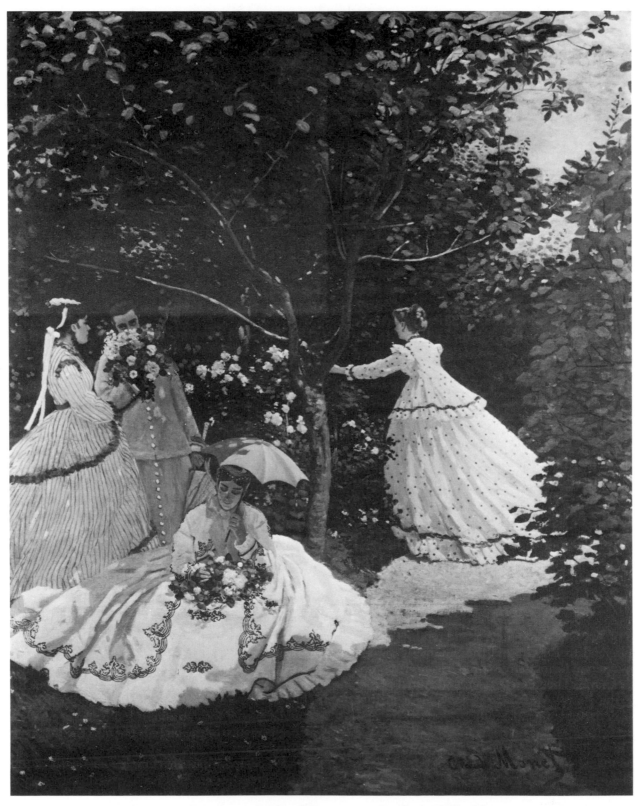

Claude Monet, Femmes au Jardin (Women in a Garden), 1867. Oil on canvas, 100½ × 80¼ in. (255.3 × 203.8 cm). Musée du Louvre, Galerie du Jeu de Paume.

The French Impressionists, like the preceding artists, recognized the opportunity for formal study inherent in flower compositions. This innovative group, with painters like Pissarro, Sisley, Renoir, Degas, and Monet, began to stimulate American artists who visited Paris in the 1880s, presenting them with fresh ideas and new techniques which they then brought back.

Claude Monet, the archetypal Impressionist painter, revealed the importance of flower painting to his artistic development when he said, "I perhaps owe having become a painter to flowers." For Monet gardening and painting became equally important, and one inspired the other. At his country estate at Giverny, he planned his flower beds as carefully as he ordered his palette: light colors predominated in both. Monet supervised six gardeners and inspected their work several times a day, and the garden bloomed from early spring to winter. During his 35 years at Giverny, Monet gave permanent form to his garden on his canvases.

The floral paradise he created there was to inspire hundreds of artists. Virtually every American Impressionist either knew about the existence of this garden or visited it. Monet's visitors included Theodore Butler, Mary Cassatt, Frederick Frieseke, John Singer Sargent, Robert Vonnoh, J. Alden Weir, and Monet's closest American friend, John H. Twachtman. Yet the American Impressionists differed from their French masters by giving greater attention to the structure and form of subject matter, to the detriment of the painting's unity. Such a concentration on individual forms is evident in Monet's advice to the American Impressionist Lila Cabot Perry, as recorded in her "Remembrances of Claude Monet" in 1927:

> Remember that every leaf of the tree is as important as the features of your model . . . When you go out to paint, try to forget what objects you have before you—a tree, a house, a field, or whatever. Merely think, here is a little square of blue, here an oblong of pink, here a streak of yellow, and paint it just as it looks to you, the exact color and shape, until it gives your own naive impression of the scene before you.

Although the American Impressionists closely followed the advice of Monet, they did not share his interest in spontaneity and immediacy. Americans such as Vonnoh and Twachtman made preparatory sketches and rarely concerned themselves with the subtle changes of light that so fascinated Monet in his waterlilies. Unlike Monet, the Americans maintained a taste for narrative or descriptive paintings. When their subjects lacked a specific narrative, some of these artists felt obliged to assign them descriptive or symbolic titles. The American paintings also contained a sweetness or sentimentality absent in the European prototypes. Often American painters would load their works with vases of flowers, or would place a beautiful girl in an orchard or garden, attired in a floral pink dress.

Although the Americans and the French shared a common interest in high-keyed colors, the American rendering was more subdued. As Barbara Novak observes in *American Painting of the Nineteenth Century*, the American denial of Impressionist high-intensity color is a further indication of their basic distrust of pure sensation, which "militated against the indigenous development of perceptual art of painterly color." Vivid colors, although somewhat subdued by comparison with French Impressionist color and light, did interest American Impressionist painters. It is not surprising then that flowers, or floral motifs, were often included in their paintings. The production of the new violet, mauve, and magenta pigments that began to appear around 1855 perhaps allowed the artist to more accurately translate the color of flowers onto the canvas. Apart from birds and tropical fish, no other aspect of nature has such brilliancy of color. One might almost say that the Impressionist painted his world with the rich, sensual color of flowers.

The American expatriate Mary Cassatt, at Degas' invitation, became associated with the French Impressionists. Like her mentor Degas, she was inspired by Japanese prints. After seeing a large exhibition of them in Paris in 1890, she produced a set of ten color prints of the *Maternal Caress*. She was preoccupied with the exploration of the mother and child theme in many of her works. The setting for these maternal subjects usually is Cassatt's own rose garden or another flower garden or orchard. Frequently the mother holds a rose, the flower traditionally associated with the Virgin. Some authorities on Cassatt's work feel that the rose does not allude to the Madonna and Child theme but is rather an expression of Cassatt's sheer delight in her garden.

Other American Impressionists, like Childe Hassam and Theodore Robinson, also depicted flowers. Hassam's watercolors and oil paintings are typified by freely brushed atmospheric interiors with fresh flowers and beautiful gardens as a feature of the compositions. Even in his later paintings of nymphs and goddesses it is possible that flowers play a part in the allegorical scheme. Robinson's use of flowers is less pronounced than Hassam's, with flowers occurring as color notations in Impressionistic landscapes.

William Merritt Chase and John Twachtman both painted flowers, although most of their works are not primarily floral. In addition to creating gorgeous pastel renderings of roses, one of Chase's favorite compositional devices was the placement of a tiny colorful flower in the distance of his landscapes. This element gives the picture a greater depth and luminosity. Chase once remarked to his students, "There is nothing more difficult than flowers. Avoid anything as complicated as that." This attitude may explain the scarceness of exclusively floral works in his oeuvre. But whatever the technical difficulties were that flowers posed for him, his few renderings of them are among the most beautiful examples of flower painting from the last decades of the 19th century. Twachtman's flower depictions are even rarer than Chase's, with the subject generally being observed in greenhouse interiors or in fields.

The growing industrialization at the turn of the century brought an end to the era in which the flower was an important subject in American art. Twentieth-century life, industrialized and urbanized, offered little inspiration for landscape and still life painters, and many artists were swept up in avant-garde cultural movements. The quiet moment necessary for contemplation of the flower was largely gone, along with the pristine beauty of the landscape. Although interest in the flower was not widespread in the 20th century, a few artists carried on the tradition. Like the earlier artists having an "artistic/scientific eye," painters in the early part of the century turned their focus to the enlarged image of the flower. Flowers came to be important, complex images incorporating the symbolic, the scientific, the technical, and the natural.

Charles Burchfield gave strongest expression to his romantic imagination in delicate animated watercolors. This medium attracted a number of early 20th-century artists and was particularly suited to depicting the fragile beauty of the flower. Burchfield's "all day" studies, his early interest, attempted to capture seasonal changes in one painting. The works had been inspired by an exhibition of Chinese scroll paintings seen in Cleveland during his student days. The same radiating animation is seen in Burchfield's flowers as in his other compositional elements: the winter sun, the dying embers of fall, June's moon, and spring's dreamy butterflies.

The Eight, a group of early 20th-century New York painters who specialized in the depiction of urban life, diverted themselves occasionally with flower painting. Among the members of The Eight, William Glackens was perhaps the most seriously concerned with flower representations. His admiration for the work of Renoir became apparent at the first exhibition of The Eight in 1908, and it is to the French Impressionists that Glackens' flower works are most closely related. Bright and colorful flowers dominate his works of 1933–38, which were the last five years of his life. These late paintings represent a continuation of the informal still life tradition of the previous century.

Charles Demuth, one of America's finest Cubist painters, showed a strong interest in flowers; his earliest known work, a small painting done around 1895, is floral, and he maintained an affection for the subject until a few months before his death in 1934. His family's garden in Lancaster, Pennsylvania, was tended mainly by his mother and was famous for its beauty. Demuth's watercolor still lifes are formed in a manner reminiscent of Paul Cézanne, whose constructional approach to fruit had already paved the way for a new articulation of the flower.

Just as Demuth is representative of the Cubist influence in American painting, Joseph Stella's work exhibits the effect of the Italian Futurists. Stella is perhaps best known for his icons to the architectural achievements of American industry, such as the Brooklyn Bridge. However, in the mid-twenties he turned to botanical subjects. He chose exotic plants whose every leaf and petal are rendered with great precision, yet delicacy. His abstract, decorative schemes heighten the strangeness of their shape and color. The results of his travels in North Africa, these fantastic plants are rife with religious and sexual symbolism. The floral works in Stella's tropical paintings of the 1930s became, as he himself described it, his "everlasting celebration of the joy of living."

Perhaps in an industrial age flowers serve as substitutes for the unspoiled, paradisiacal landscape of the 19th century. Georgia O'Keeffe records the beauty and color found in flowers in much the same way as she recreates the psychological impact of buildings. Influenced by Stella's work, O'Keeffe worked early in her career with Arthur Wesley Dow, a student of Gauguin. O'Keeffe shared with Dow a rejection of realism in favor of simplification, abstract patterning, and coloristic harmonies. Her interest in flowers appeared as early as 1919–20, with such works as *Red Canna*, and continued through the late 1940s. Her flower paintings derive their impact from a magnified image that intrudes on the viewer's space. Although O'Keeffe has denied any conscious sexual reference in her flower paintings, the viewer is bound to relate to the work on many different psychological and esthetic levels.

There is perhaps a parallel between the style of painters of the late 19th century, and the late 20th-century artists' use of flowers. Young painters of the 1940s who are identified with the dissolution of narrative subject matter, such as Arshile Gorky, Franz Kline, and Helen Frankenthaler, depicted flowers only occasionally in the early stages of their careers. In the 1960s, however, the intense color which had concerned flower painters of the 19th century became a central issue. Paintings were then exclusively about color, and flowers were the principal natural source. Another common concern of 19th-century flower painters and artists of the 1960s was the creation of a sensuous, fragile surface. The new artists' attention to the surface of canvas—unprimed, without varnish, and exposed to the elements—was analogous to earlier careful observation of the fragile petals of a flower.

It is evident that the history of American flower painting is not simply a matter of the development of a still life genre. Flowers in colonial portraiture alluded to the colonist's position in God's new world. By the mid–19th-century, flowers professed love in lieu of words, and demonstrated the artist's "artistic/scientific eye." To the Impressionists, flowers were the inspiration for the color with which they infused their canvases.

Flowers, when used as subject and symbol in American painting, have inspired a style—like the American landscape and the American portrait—that is unique to the culture it represents. It is a style derived from ancient traditions and melded with contemporary usages. Most important, the development of flower painting in America symbolizes the growth of man's perception of the world, and of how he chooses to represent the change.

Color Plates

PLATE 1

Charles Willson Peale (1741–1827)

PORTRAIT OF MRS. GEORGE SUTTON (RACHAEL BOLITHO)
Oil on canvas, 23 × 19 in. (58.4 × 48.3 cm)
Colby College Museum of Art, the Mr. and Mrs. Ellerton M. Jetté Collection

Charles Willson Peale—a trained saddlemaker, upholsterer, sign painter, silversmith, and scientist—was one of the most knowledgeable and versatile Americans of his day. Around 1860 he sought out John Hesseluis, who gave him, in exchange for a saddle, instructions in portrait painting. Peale's talent developed so quickly that six years later his work attracted the attention of John Beale Burdley, a member of the Massachusetts Governor's Council, who subsequently gathered funds to allow Peale to study in London with Benjamin West. Despite his admiration for West's historical and monumental paintings, Peale continued to be fascinated with smaller paintings and miniatures. While in England Peale no doubt came in contact with the European tradition of using flowers in rich, allegorical statements, for this tradition was incorporated into his portraits. Often Peale was called upon to paint the portrait of persons who, for one reason or another, suspected they hadn't long to live. Because of the high mortality rate during childbirth, Peale painted many portraits of expectant mothers; it was especially common for the young mother-to-be to have her portrait painted when expecting her first baby.

Flowers were important adjuncts in the American portrait tradition. Although many itinerant painters included the imagery without knowing the symbolism—merely thinking it was tasteful according to European standards—Peale not only uses the appropriate rose symbol in his maternal portraits, but in a more general way, his use of flowers indicates the transiency of human life.

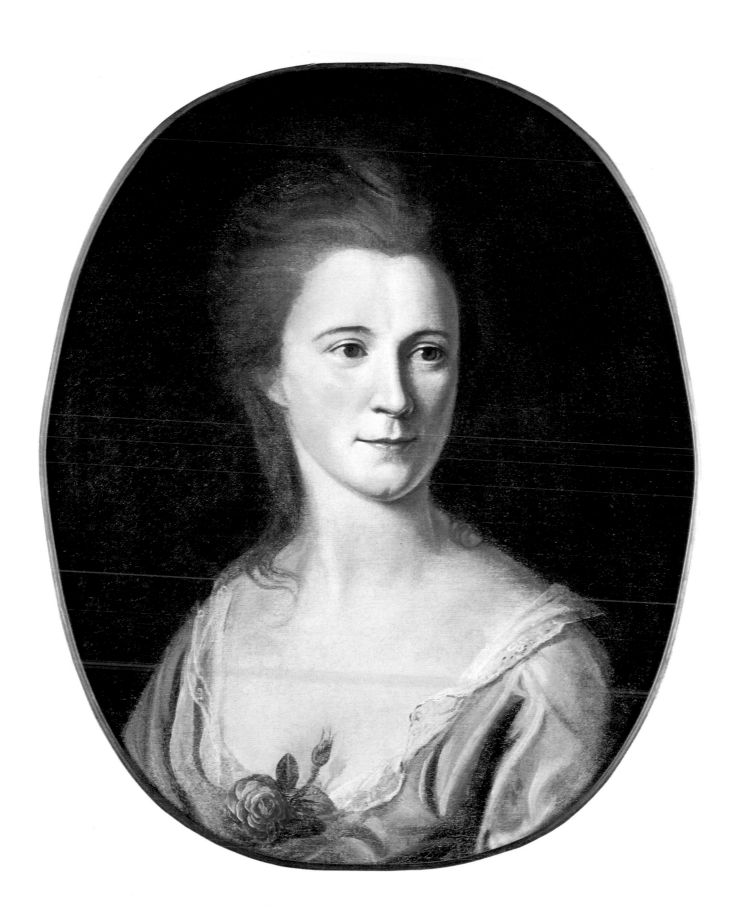

PLATE 2

Rembrandt Peale (1778–1860)

RUBENS PEALE WITH A GERANIUM, 1801
Oil on canvas, 28 × 24 in. (71.1 × 61 cm)
Collection of Mrs. Norman B. Woolworth

Rembrandt Peale was the son of Charles Willson Peale and he, like his father, had a great interest in both science and art. From a remarkable family of artistic brothers, sisters-in-law, and one sister, Rembrandt and Rubens were perhaps the most talented. *Rubens Peale with a Geranium* is a masterpiece. At the time of the painting, Rembrandt was assisting his father in a scientific project, exhuming mastodon skeletons in Ulster County, New York. The following year, he and his brother Rubens accompanied an exhibition of the skeletons to England. The Peales' interest in paleontology, Carl Linnaeus, and in making oblique references to scientific endeavors in their painting, epitomizes the idea of the "artistic/scientific eye."

In the preface to his notebook, which was a collection of writings that interested him, Rembrandt recorded a passage by W. Howitt:

> Of all the minor creations of God, flowers seem to be most completely the effusions of His love of beauty, grace, and joy. Of all the minor objects which surround us they are the least connected with our absolute necessities. Vegitation [sic] might proceed [sic], the earth might be clothed with sober green; all the process of fructification might be perfected without being attended by the glory with which the flower is crowned; but beauty and fragrance are poured over the earth in blossoms of endless varieties, radiant evidences of the boundless benevolence of the Deity. They are made solely to gladden the heart of man, for a light to his eyes, for a living inspiration of grace to his spirit, for a perpetual admiration.

Peale saw the work of God's hand in nature. Through scientific investigation, Rembrandt used his own hand to explore his world, and to examine and understand his origins. This same investigative hand executed his paintings, thereby revealing the interface of art and science.

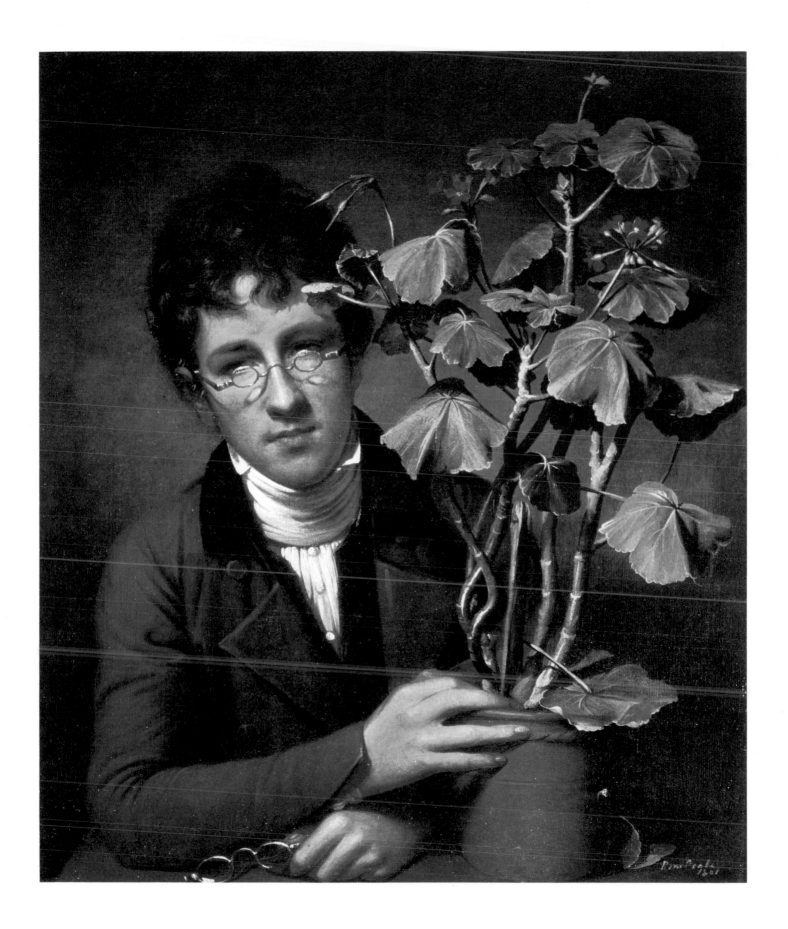

PLATE 3

Severin Roesen (?–c. 1871)

STILL LIFE: FLOWERS, c. 1855
Oil on canvas, 40 × 50⅜ in. (101.6 × 128 cm)
The Metropolitan Museum of Art, Purchase, Charles Allen Munn Bequest; Fosburgh
Fund, Inc. Gift; Mr. and Mrs. J. William Middendorf II Gift; and Henry G. Keasbey
Bequest, 1967. Copyright 1980 by The Metropolitan Museum of Art

Roesen was a porcelain and enamel painter as well as a painter of still lifes. He worked in Cologne, Germany, where his work was exhibited in 1847. He emigrated to New York the following year, and in 1857 moved to Williamsport, Pennsylvania.

Roesen's succulent arrangements of food and fruit, which sometimes included flowers, related specifically to the German Baroque tradition. Perhaps it was the heaviness of this grandiose style that later prompted the American public to prefer a style of austere simplicity and elegance. The many layers in this fruit and flower composition may, however, allude to more than elegance, and in fact may serve to more than just fill up the canvas. Here hundreds of different kinds of fruit and flowers seem to be systematically compared in size, color, texture, weight, and shape, and one can sense the same "artistic/scientific eye" that is evident in the work of Martin J. Heade and the Peales. As was true of the Peale family, science and religion went hand in hand for Roesen, and ultimately the differences in forms and colors emphasized in his work are his expression of the greatness of God.

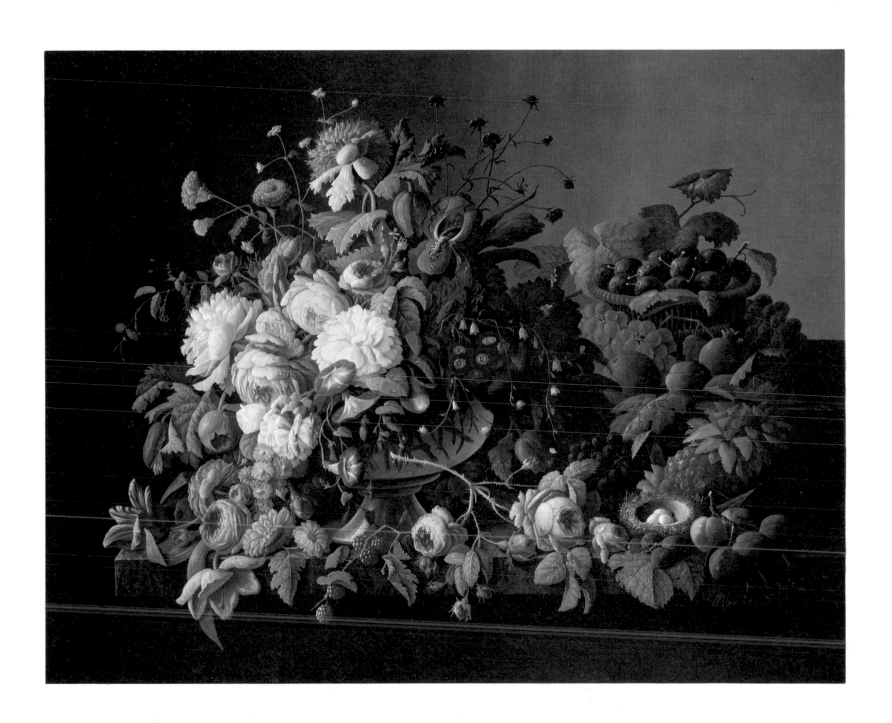

PLATE 4

James Abbott McNeill Whistler (1834–1903)

THE WHITE GIRL (SYMPHONY IN WHITE NO. 1), 1862
Oil on canvas, 84½ × 42½ in. (214.6 × 107.9 cm)
National Gallery of Art, Washington, D.C., Harris Whitmore Collection

Whistler went to Paris in 1855 to study painting, and four years later moved to London where he remained the rest of his life. From there, he often visited France, where he had close contact with the Impressionist movement.

The titles of Whistler's paintings are abstract—*Nocturnes*, *Harmonies*, *Arrangements*—as were his conceptions of them. For him the important consideration in creating a work of art was not the imitation of nature, but the use of nature as a "key," as a source which the artist should rearrange in a new and meaningful way. Influenced by the ideas of Edouard Manet, Whistler wanted the canvas to be appreciated for its formal qualities alone. So, he strongly advocated the idea of "art for art's sake." In *American Art, 1700–1960: Sources and Documents*, John McCoubrey records Whistler as having once said: "The imitator is a poor kind of creature It is for the artist to do something beyond this . . . in arrangement of colors to treat a flower as his key not his model." Whistler used the flower as an abstract form in his composition, not as a direct model.

The White Girl demonstrates Whistler's formal concern for white as a color. Such concerns are also revealed in his *Arrangement in Gray and Black No. 1* which, as is commonly known, is Whistler's mother. Whistler created ambiguity by giving abstract titles to portraits of his friends and family, for the titles denied all reference to his models and their personal attributes. The scandal generated by the disheveled appearance of *The White Girl*, who was actually his mistress Jo Hefferman, certainly must have prompted him to rename the picture *Symphony in White No. 1*. However, the public was not to be distracted from Whistler's key subject and its symbolism.

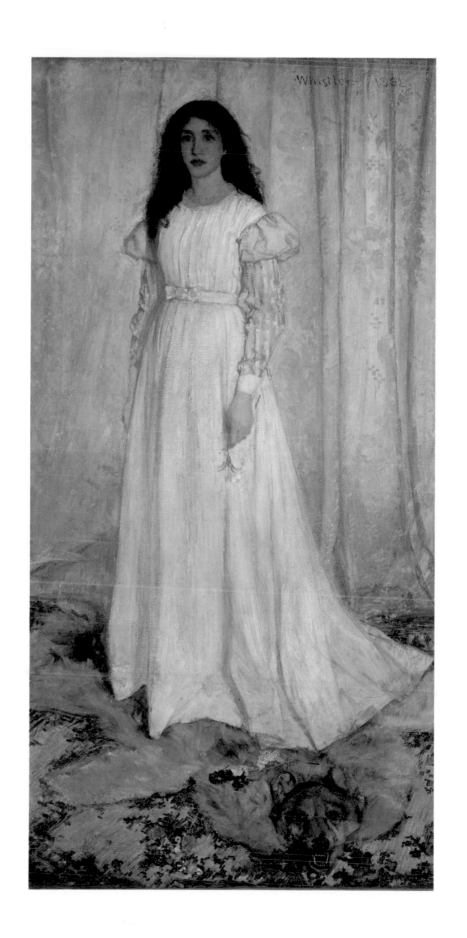

PLATE 5

John La Farge (1835–1910)

FLOWERS ON A WINDOW LEDGE, 1862
Oil on canvas, 24 × 20 in. (61 × 50.8 cm)
In the collection of the Corcoran Gallery of Art, Anna E. Clark Fund

In 1856 La Farge went to Paris to study with Thomas Couture, and afterwards went to London to work with the Pre-Raphaelites. Upon his return to the United States, he studied in Newport, Rhode Island, with William Morris Hunt, who was the leading naturalist of the time. It was three years later, at La Farge's family house there, that *Flowers on a Window Ledge* was painted.

In this painting La Farge loosens the detailed style of depiction and the "botanical naturalness" practiced by John Hill and William Morris Hunt. As expressed in his own words, La Farge develops his light "in terms of the nuances of the clarity and brilliance between the outdoor lights and those within the room." La Farge began to paint flower still lifes as early as 1859. Often the flowers were removed from their natural setting and placed in a bowl, usually on a windowsill or table. He sought to portray the inner life and soul of the flower, its meaning, rather than its biological structure. Here the blooms are surrounded by an atmospheric veil of light. The impact of La Farge's interest in Japan is evident in the strong diagonal drape and in the feeling of deep space contrasting with the sense of overall flatness caused by his pale harmony of colors.

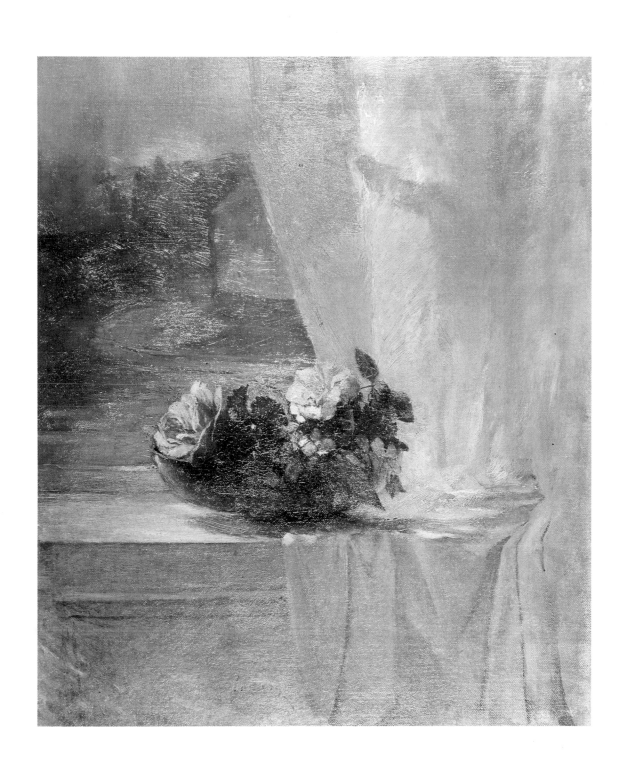

PLATE 6

John William Hill (1812–1879)

TEAROSES IN LANDSCAPE, 1894
Watercolor, 14 × 20 in. (35.6 × 50.8 cm)
Courtesy of Hull Gallery, Washington, D.C.

John William Hill's father, John Hill, was an important engraver and aquatintist whose realistic works were characterized by a pen and ink outline with color washes. The son was a prolific watercolorist who founded the New York Water Color Society. John William's work before 1850 was loose and tonal, as compared to his later works, which were tighter and more colorful. These later works show his adaptation of the ideas of John Ruskin, the Pre-Raphaelites, and the up-to-date English watercolor style. Hill knew Ruskin and followed his ideas with care. His paintings of birds' nests and flowers exemplified the naturalist approach with their high-keyed colors, their chance arrangement, and an absence of contrived and grandiose composition. The heavy white ground penetrates the finely stippled strokes of translucent watercolor, and conscientious rendering emphasizes detail, typifying the Pre-Raphaelite ideal in America.

Hill's depictions evidenced his interest in "American Light," which refers to a uniquely American way of observing light, and the complex term "Luminism," which was first used by historian J. I. H. Baur to describe the technique of portraying light as an ethereal glow with no brushstrokes visible. Theodore Stebbins, an authority on American art, writes in his *American Light* catalogue: "The years from 1855 to 1875 were exactly those which saw the rise of a small group of Americans working in something close to the Pre-Raphaelite style . . . (including Hill), like the Luminists, they were closely allied to the Hudson River School, they exhibited at the National Academy of Design, and they also were carrying on a quintessentially British style in the face of increasing French influence."

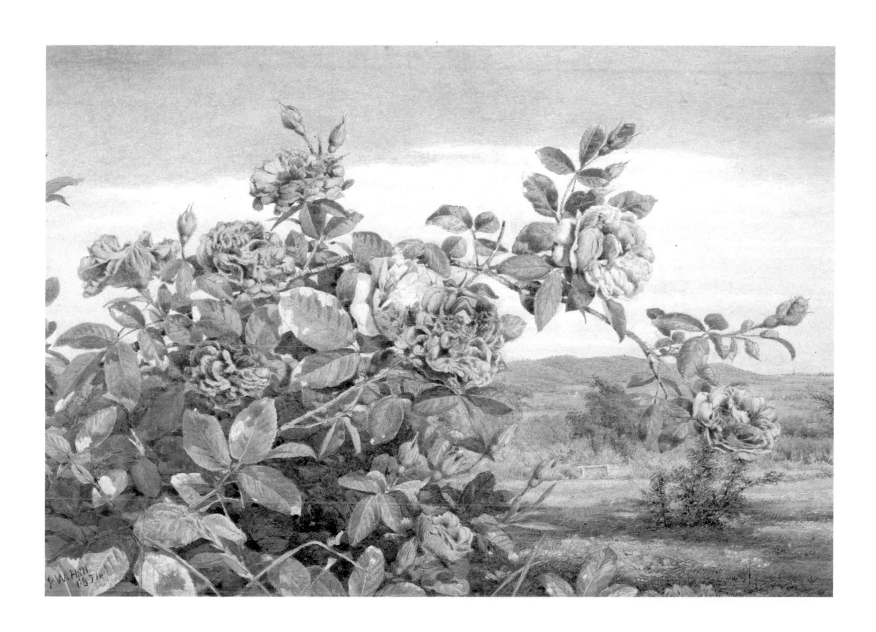

PLATE 7

Ralph A. Blakelock (1847–1919)

RED ROSES (PINK ROSES)
Oil on canvas, 12½ × 10 in. (31.8 × 25.4 cm)
Collection of R.S. Schafler

Born in New York, Blakelock studied in the public schools, and what is now called City College. Despite the emphasis of his earlier works on literal detail, his paintings reveal a romantic love for the lonely landscape and the still life. Blakelock's attraction for the American wilderness, in fact, kept him in this country while his contemporaries turned to Europe for inspiration. Still lifes, like portraits, comprise only a small portion of his output. There are only nine such subjects left; a tenth has been lost. Although moonlit landscapes were the focus of his interest, Blakelock's absorption with the mystery of darkness penetrated all his work.

The dark background in this still life alludes to the nighttime. The artist's choice to depict the rose at night—veiling the most brilliant of nature's flowers in darkness—is at the same time subtle and romantic. The veil of darkness so transforms the color of the flowers that the painting is sometimes called *Pink Roses*.

However, elaboration of color never had as much of an appeal to Blakelock as it had to other painters. He would be perfectly content to remove the detail from objects and place them in mysterious silhouette. Many of his moonlit landscapes, for instance, have trees and Indian encampments painted in silhouette. As stated in a review of the Blakelock Centenary Exhibition in the *Christian Science Monitor* in 1947, it was not color but "feeling, pure and simple" that was Blakelock's concern. His nighttime flower paintings, then, allude to deep feelings of mystery, romance, and loneliness, thus endowing his flowers with a wide metaphorical vocabulary.

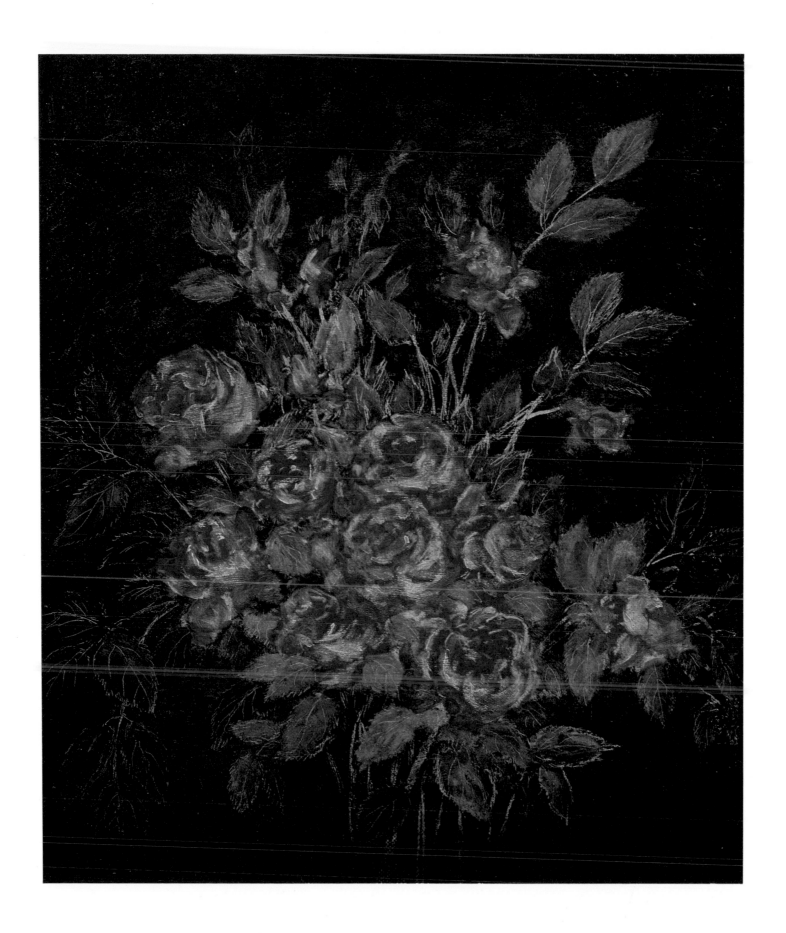

PLATE 8

George Cochran Lambdin (1830–1896)

ROSES
Oil on panel, 24 × 12 in. (61 × 30.5 cm)
From the Collection of Mr. and Mrs. George J. Arden

In his time, George Cochran Lambdin was better known for his narrative Civil War depictions than he was known for his use of flowers. However, floral still lifes did dominate his works from the 1850s to the 1870s. He cultivated roses and painted many of them, and perhaps for this reason some of his most sensational works are depictions of these flowers at their peak, while still blooming on the vine. His rose-garden paintings as well as his still lifes were widely exhibited, and chromolithographs of the pictures were published by the leading lithographer Louis Prang. In retrospect, Lambdin can perhaps be called the first major American flower painter.

Lambdin's flowers are often painted against a black or dark background, a fashion introduced by him and copied by a number of his contemporaries. His paintings of bouquets, like his other works, are filled with sentiment and romance. They would often be sent to a loved one, for in the vocabulary of flowers Lambdin's works expressed "true love." In Prang's 1878 catalogue of chromolithographs, for example, the titles of some of Lambdin's paintings were *White Lily*, *Calla Lily*, *Fuchsias and Roses*, *White Azaleas and Tea Roses*, and *Roses and Buds*—all known to have love messages associated with them according to the floral dictionaries of the time. Prang paid Lambdin about sixty dollars for one of his creations and, with the growing demand for inexpensive decorative works during that period, Prang's prints of Lambdin's flowers hung in many a Victorian parlor.

PLATE 9

Martin Johnson Heade (1819–1904)

TWO FIGHTING HUMMINGBIRDS WITH TWO ORCHIDS, 1875
Oil on canvas, 17½ × 27¾ in. (44.5 × 70.5 cm)
Collection of the Whitney Museum of Art, Gift of Henry Schnakenberg
in memory of Juliana Force

The publication of Charles Darwin's *Origin of Species* in 1859, as well as his later published research on plants and flowers, brought scientific study to the attention of the art world, first in Europe, then in America by the late 1870s. Darwin's vision of nature altered the way many flower painters treated their subject matter: flowers came to be seen not only as symbols of sentiment but also as objects of scientific investigation.

The famous paintings of orchids and hummingbirds that resulted from Heade's trips to Brazil depict with minute accuracy the structures both of the flowers and of the birds. The artist must have been familiar with Darwin's publications on the fertilization of orchids, and must have been cognizant of the sexual meaning of the orchid and attendant hummingbirds when he selected them as subjects. Heade's reticence concerning the underlying intent of these paintings was a result of Victorian prudery. Although they were suppressed in works intended for the general public, allusions of a sexual nature were included in sophisticated art and literature. Just as Heade depicted the orchid with its multiple connotations, Nathaniel Hawthorne, in his short story *The Intelligence Officer*, employed white roses, blush roses, and moss roses as emblems of unawakened sexuality, and Edgar Allan Poe associated exotic flowers with sexual bliss in the short story *Eleanora*.

Heade was preoccupied with the orchid in his art for over thirty years. What was it about the orchid that fascinated him? An excerpt from his notebook may provide an explanation:

> Every man who possesses a soul has loved once, if not a dozen times, for passion was created with man, and is a part of his nature . . . As soon as the affectionate and sensitive part of my nature leaves me, I shall consider the poetry of my existence gone, and shall look upon life as a utilitarian, bargain-and-trade affair; for the poetry is the only real source of happiness we have, and I care not whether it is laughed at or acknowledged.

In his compositions, Heade interrelates the complex variety of artistic concerns existing in the 19th century—the traditional still life genre, the epic landscape, the new attention to scientific observation, and formal manipulations of light, color, and texture. He is the model of the artist with an "artistic/scientific eye," and his works are among the most sophisticated of his time.

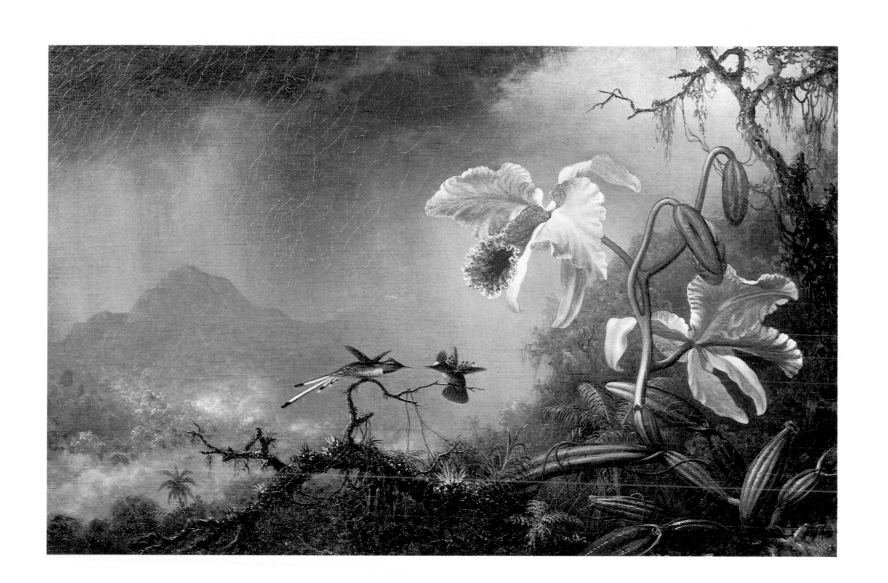

PLATE 10

Eastman Johnson (1824–1906)

HOLLYHOCKS, 1876
Oil on canvas, 25 × 31 in. (63.5 × 78.8 cm)
From the collection of the New Britain Museum of American Art
(Harriet Russell Stanley Fund)

Post–Civil War Americans were eager to forget the horrors of war. Perhaps for this reason artists depicted the pleasures of the working class: music, art, leisure, vacation, and sports. It is for these scenes that Eastman Johnson is best known. Europeans at the same time wanted release from the urban crowding caused by the influx of others like themselves who came to the cities from rural homes.

Monet's *Women in a Garden* (see p. 14) exemplifies the French Impressionist interest in beautifully dressed women in flower gardens. Flowers were not only the objects of color and spatial notes, but they were gathered in bouquets, adored and gazed at, as if romance itself were in the young ladies' arms. Interestingly, hollyhocks are defined in floral dictionaries as flowers of "salvation," a term as familiar to the Victorian vocabulary as that flower was to the Victorian garden. In *Hollyhocks*, Johnson follows the Pre-Raphaelite ideal, and depicts deep space realistically, with the most distant figure lost in the shaded background. Here light and shadow are convincingly rendered. In Monet's *Women in a Garden*, by contrast, the light and shadow are not logically described, and he depicts a fantasy world of sorts which heightens the dream-like reverie of his subjects. In Monet, the figures almost overpower nature; in Johnson, the hollyhocks overpower the figures.

PLATE 11

Abbott H. Thayer (1849–1921)

ROSES, c. 1897
Oil on canvas, 12 × 20 in. (30.5 × 50.8 cm)
Collection of Mr. and Mrs. Raymond J. Horowitz

In 1867 Thayer moved to Brooklyn where he attended the Brooklyn Art School; later he studied at the National Academy of Design in New York. In 1875 he went to Paris where he entered the Ecole des Beaux Arts and studied in the atelier of Jean Léon Gérôme. An academician, Gérôme's use of the tight, classical style together with his choice of exotic subjects—Morocco, Tangiers, Roman gladiators—places him as a precursor of the Impressionists. Five years later when Thayer returned to America, he had become immersed in the Pre-Raphaelite idealized vision of woman, which took its measure in Renaissance painting and in neoclassical iconography. In addition to the woman theme—Madonna, winged angel, Virgin—Thayer also painted still lifes of roses. The symbolic relationship of the two subjects seems too coincidental to overlook. In fact, one could represent the other: the rose may indicate the Virgin and vice versa. Like his contemporary La Farge, Thayer is concerned with a dramatic inner luminosity, as well as a sensitive modeling of the leaves and petals.

Thayer was concerned with a naturalist approach in painting plants, and in addition, he was interested in ornithology and in the camouflage effects found in nature. In 1909 he published the book *Concealing Coloration in the Animal Kingdom*, which was illustrated with watercolors done by himself and his son Gerald Thayer. These illustrations were the result of years of travel and observation. Abbott clearly separated this illustrative work from his ideal paintings, stating in the December 1884 issue of *American Painters in Pastel*, "I have to work up through this 'science load' that accumulates on my shoulders, to my art, because in that I must be wholly free." Even so, his interest in science, art, and mythology is also reflected in his fine art.

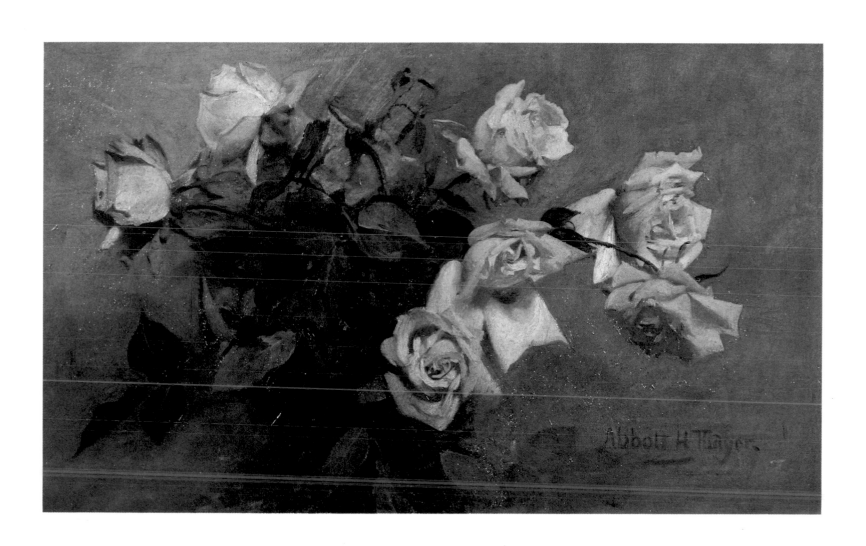

PLATE 12

Emil Carlsen (1853–1932)

PEONIES IN KANG HSI VASE, c. 1885
Oil on canvas, 39 × 56 in. (99 × 142.2 cm)
Private collection

Carlsen was born in Copenhagen in 1853, and studied architecture at the Danish Royal Academy there. In 1872 he emigrated to the United States and settled in Chicago, where he worked as an architectural assistant. However, he began to make marine sketches and discovered his interest in art, and some six months later returned to Europe to begin his new career there. Carlsen came back to America in 1875 and began teaching at the Chicago Art Institute. Later he went to teach at the California School of Design where he became director.

In 1884 a New York art dealer named Blakeslee saw Carlsen's still life paintings and commissioned him to travel to Paris to work. From Paris, Carlsen would send his paintings back to New York to be exhibited and sold, thus filling the growing demand for French-influenced paintings. It is from this period that *Peonies in Kang Hsi Vase* comes.

Carlsen specialized in these beautifully composed still lifes, which are reminiscent of works by Whistler, Dewing, and especially William Merritt Chase. He often incorporated Oriental vases into his pictures, using them to hold the flower arrangements. In this way Carlsen helped to introduce to the American public the Chinese/Japanese motif that rapidly grew in popularity.

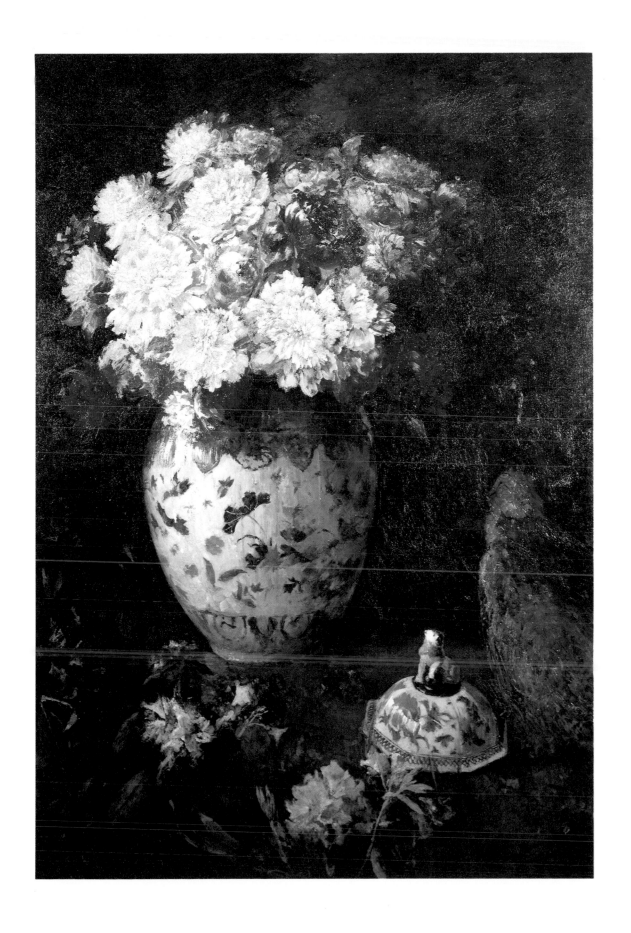

PLATE 13

William Merritt Chase (1849–1916)

FLOWERS (ROSES), c. 1884–1888
Pastel on paper, 13 × 11⅜ in. (33 × 28.9 cm)
Collection of Mr. and Mrs. Raymond J. Horowitz

William Merritt Chase, teacher of such important artists as Georgia O'Keeffe, Charles Sheeler, Charles Demuth, Rockwell Kent, Edward Hopper, and Alfred Maurer, was one of America's most important painters himself. Born in Indiana, Chase moved to New York in 1870 to study at the National Academy of Design. His travels abroad began in 1872 when, through the generous support of Indiana patrons, he was able to go to Munich to further his studies. There he met Frank Duveneck and John H. Twachtman, and later went to Venice in their company. In 1881 Chase went to Spain and spent three summers there studying the works of Velazquez. He met Whistler in 1885, and they developed a brief but warm friendship. Around that time, Chase also began applying to his paintings the color techniques that he admired in the many 17th-century Dutch paintings he had seen on his travels. He was particularly affected by the Dutch portraits and still lifes. When Chase returned to New York, he established residence in his renowned Tenth Street Studio. For nearly thirty years, this studio and his summer school in Shinnecock, Long Island, were his bases. The period from 1880 to 1900 marked the most important part of Chase's career. He was much influenced by his travels, the European works he saw, and the artists who became his friends.

Although Chase is famous as a painter for his works in oil, it is in the medium of pastel that he truly demonstrates his mastery. As explained by Ronald G. Pisano in *William Merritt Chase*:

> Chase achieved the highest and most consistent quality in his work in pastel . . . with the pastel medium Chase was able to achieve bright hues and soft textures unattainable in oil; the small competitive group of the Society of Painters in Pastel inspired Chase to produce works of especially high quality; and finally, neither Chase nor the other members of the society thought of pastels as a "drawing medium," as is clear in their choice of a name for the organization.

Flowers is not only one of Chase's masterpieces in pastels, but it sits among the three or four finest works on the floral subject in the entirety of American art.

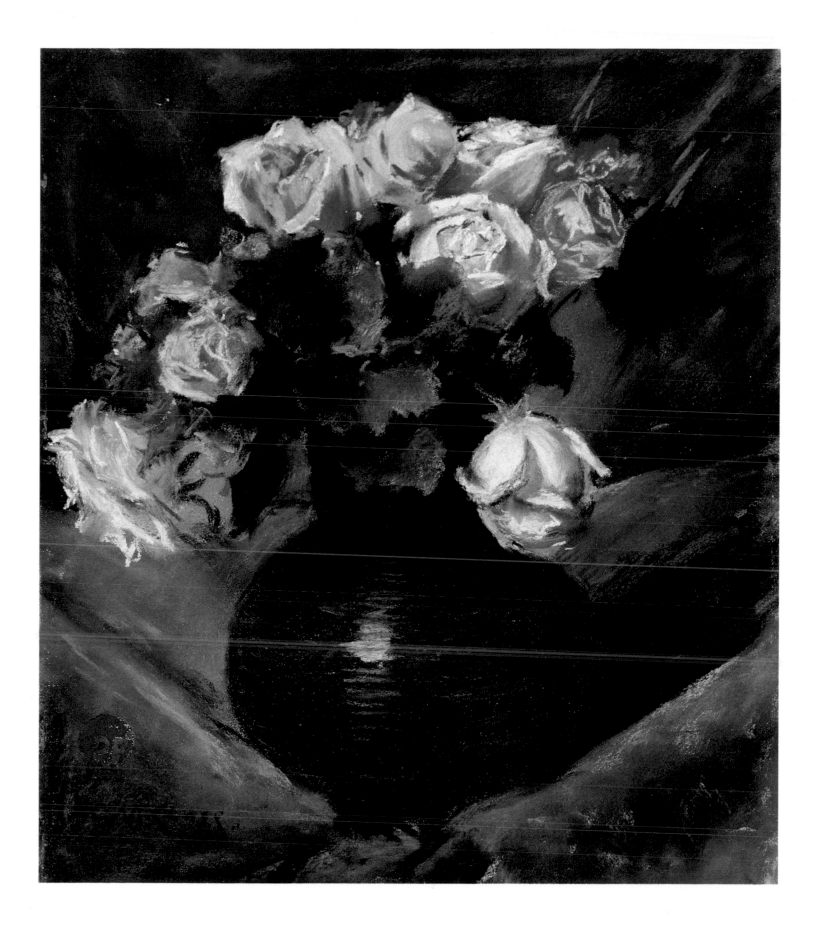

PLATE 14

J. Alden Weir (1852–1919)

ROSES WITH FIGURE AND GOBLET, 1886
Watercolor, 17½ × 12¼ in. (44.5 × 31.1 cm)
Collection of Erving and Joyce Wolf

J. Alden Weir was born into an artistic family. His father, Robert, taught drawing at the United States Military Academy from 1834 to 1876, and among his pupils were future generals Grant, Lee, Sherman, and the renegade of the group, James McNeill Whistler. Naturally, J. Alden first learned to draw from his father. Around 1867 Weir left for New York to study at the National Academy of Design, where two of his classmates were Albert Pinkham Ryder and William Merritt Chase. Six years later he went to Paris, where he studied first with Gérôme and later with Jules Bastien-Lepage. He was to visit Europe frequently thereafter—in 1876, 1878, 1880, and 1881—and was drawn to the works of Velazquez, Hals, Raphael, Dürer, and Holbein.

A founding member of the Society of American Artists, Weir also belonged to the National Academy of Design. *Roses with Figures and Goblet* probably was exhibited in 1886 at the National Academy on the 19th anniversary of the American Watercolor Society. In February of that year, a critic of *Art Age* wrote: "Mr. J. Alden Weir's pale roses and dusty curios have a charm of spirituality, and the suggestion of decay which belongs rather to Old World Art than to new."

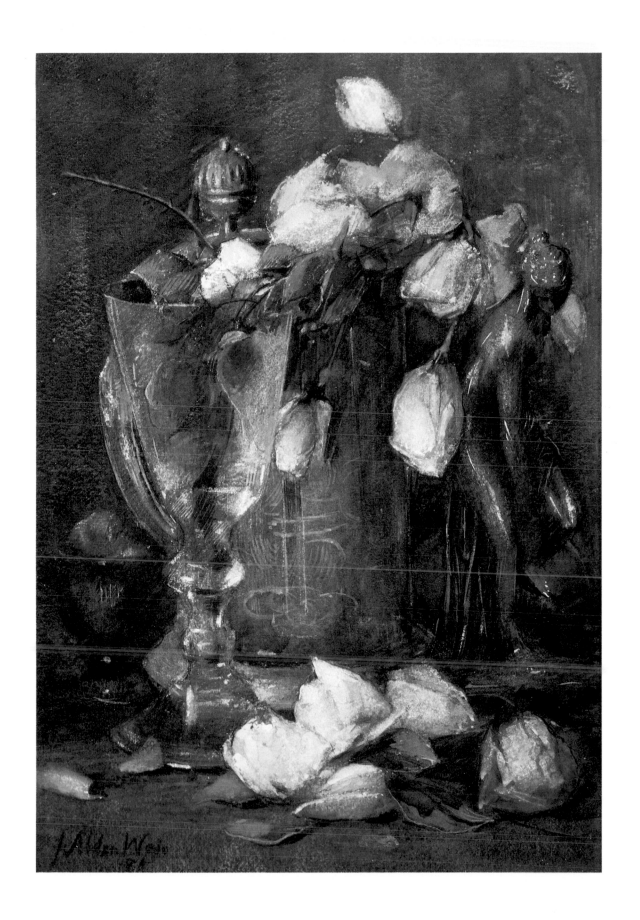

PLATE 15

Robert Vonnoh (1858–1933)

POPPIES, 1888
Oil on canvas, 13 × 18 in. (33 × 45.7 cm)
Indianapolis Museum of Art, James E. Roberts Fund

In 1887 Vonnoh traveled to Europe where he encountered Monet's paintings of the Giverny flowers. From then on his paintings adopted higher-keyed colors and the dissolution of form found in the Impressionist style. When Vonnoh returned from Europe in 1891, he brought his version of Impressionism to the Pennsylvania Academy of the Fine Arts, where he was the principal instructor for five years. While there, his students included Edward Redfield and Elmer Schofield, as well as the young painters William Glackens, John Sloan, and Robert Henri, who would later become members of The Eight.

Although Vonnoh is best known as a portrait painter and teacher, his landscapes are important for being some of the earliest American Impressionist paintings. For instance, *Poppies* predates many of William Merritt Chase's Shinnecock paintings and most of the works of Hassam, Twachtman, Weir, and Robinson. Vonnoh's relative obscurity is hard to explain, but perhaps it is a consequence of his interest in portraiture, a less highly regarded genre at the time, which has diverted attention from his landscapes.

A comparison can be made between this painting and the later works of Monet. Flowers, that highly favored subject of the Impressionists, appealed to the refined eye of Monet and similarly to the thirty-year-old Vonnoh. Vonnoh's patterning of the nearly flat floral motif and the delicacy, subtlety, and beauty of *Poppies* rival Monet's exquisite floating waterlily paradise.

PLATE 16

Mary Cassatt (1824–1926)

LILACS IN A WINDOW, 1889
Oil on canvas, 24½ × 20 in. (62.3 × 50.8 cm)
Private collection, New York

The daughter of a prosperous Philadelphia businessman, Mary Cassatt spent much of her childhood in France and Germany. After attending the Pennsylvania Academy of the Fine Arts from 1861 to 1865, she left for Europe. She visited Italy in 1872 to study Correggio, and continued on to Spain to see the works of Velazquez. She also traveled to Holland where she was exposed to the paintings of Rubens and Hals. Eventually Cassatt settled in Paris and began to paint.

Her earlier works were accepted in the Paris Salon for five consecutive years, but in 1877 her paintings were rejected—probably because of her palette's shift to higher-keyed colors while the subjects remained the same. It was during this year that she met Degas and was invited by him to join a group of advanced painters whose views were more sympathetic to hers. Like Degas, Cassatt had little interest in landscape painting, but she was inspired by Japanese figurative prints. She became preoccupied with the theme of mother and child, and often set these maternal scenes in a garden or orchard. Although her frequent use of flowers in these paintings brings to mind a symbolic relationship between the flowers and her subject matter, Adelyn Breeskin, foremost authority on Cassatt's work, feels that Cassatt did not plan the rose as a specific allusion to the Madonna and Child theme. Instead she feels that Cassatt's delight in gardens is the simple cause for the occurrence of flowers in her works.

Lilacs in a Window is one of the few Cassatt paintings that is completely floral. Like the accessory florals included in Cassatt's maternal works, they are here to be enjoyed for their freshness and beauty.

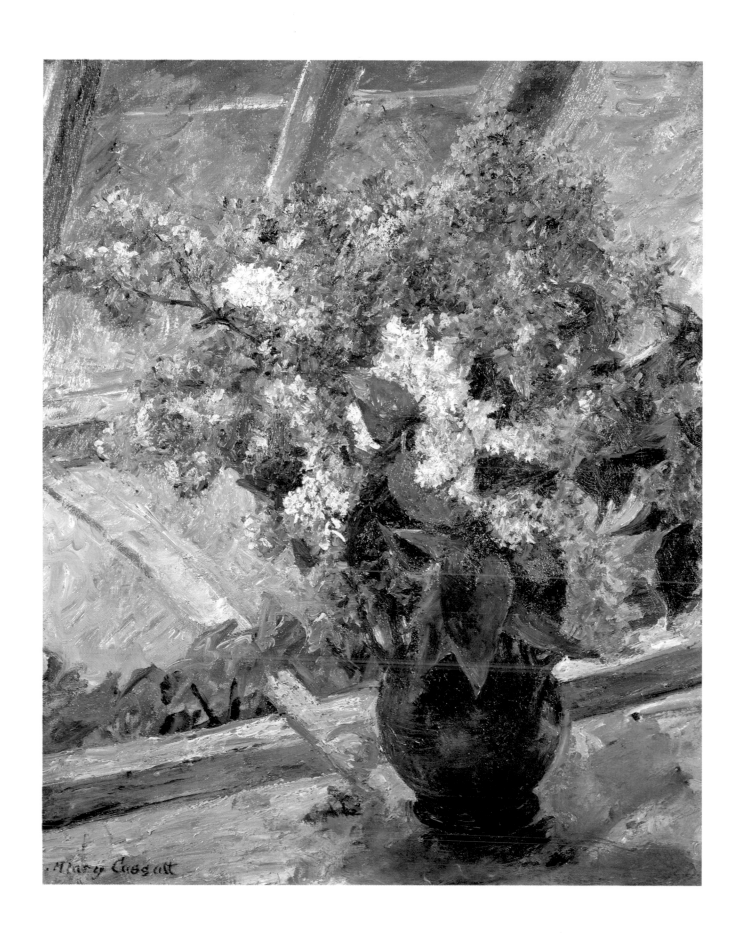

PLATE 17

Frederick Childe Hassam (1859–1935)

CHEZ LA FLEURISTE, 1889–1890
Oil on canvas, 36¾ × 54¼ in. (93.3 × 137.8 cm)
The Chrysler Museum, Norfolk, Virginia, Gift of Walter P. Chrysler, Jr.

Childe Hassam was one of the first American painters to practice the principles of French Impressionism. His use of rich textures and broken colors to depict sunlight and atmosphere securely ties him to that movement. In 1886 Hassam left Boston, where he was then staying, to go to Paris and study under Gustave Boulanger and Jules Lefebvre at the Académie Julian. His works of the next three years vacillated in style between tight academic drawing and the lighter, looser brushwork of the Impressionists. He continued to explore the atmospheric effects of gray, rainy days, which was a subject he had first become concerned with in Boston. Hassam's early style may have been stimulated by the work of Claude Monet which was exhibited at the Galerie Georges Petit in 1889.

 In *Chez la Fleuriste*, Hassam also shows the influence of Whistler's revolutionary use of white as a color. He accentuated the freshness of the flowering plants with their white protective wrappings. Although flowers are rare in the works of Hassam, rarely are finer works by him to be found.

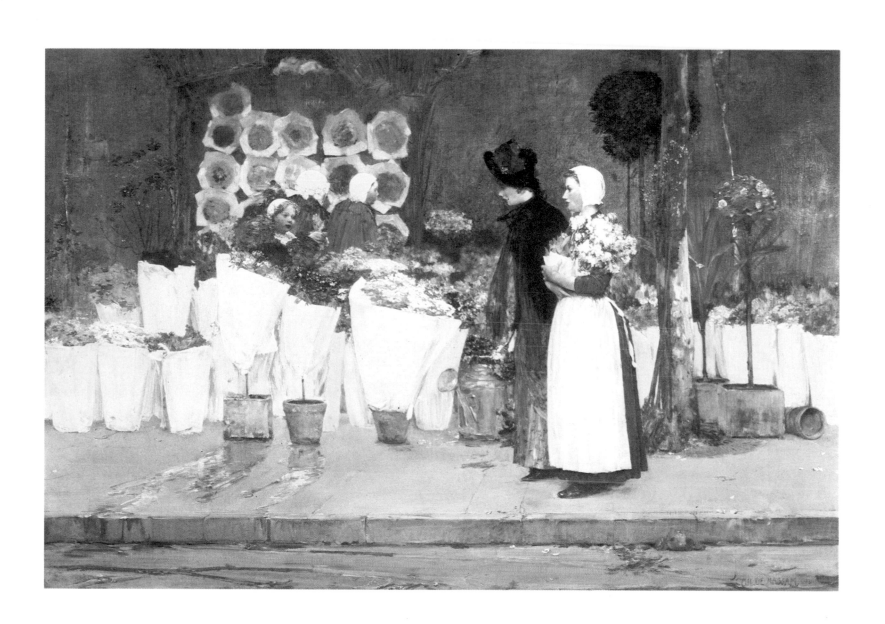

PLATE 18

John Henry Twachtman (1853–1902)

IN THE GREENHOUSE, c. 1890–1900
Oil on canvas, 25 × 16 in. (63.5 × 40.6 cm)
Collection of the North Carolina Museum of Art, Raleigh

Twachtman was a landscape painter from the outset. Although he did attempt a few figural pieces, he was most comfortable painting nature with its qualities of silence and isolation. His feeling for the land probably grew out of his experience on his father-in-law's farm. Twachtman responded most profoundly to the winter season, when "that feeling of quiet and all nature is hushed to silence." In the snowy scenes that he often painted, Twachtman used white for a main color, a technique he may have derived from his familiarity with Whistler's works of the mid-1860s.

In his landscapes, Twachtman was more engaged with capturing the ephemeral atmosphere of the seasons, and with his personal interpretation of nature, than he was with practicing the Impressionists' idiom of light and shadow. However, the externalization of his vision, with its total blurring of form in shimmering color, likens him to Monet. Both men were interested in realistically describing the vibrancy of color and reflections to be found in glass and water—those elements which distort and change nature.

Also like Monet, Twachtman was interested in gardening. Depicted here is the interior of the artist's greenhouse. Twachtman's few flower paintings were done at the end of his career, and like his earlier snow scenes, they are delicate, subtle, and memorable.

PLATE 19

Maurice Prendergast (1859–1924)

FLOWERS IN A VASE, c. 1917
Oil on canvas, 23¼ × 25³/16 in. (59 × 64 cm)
The Brooklyn Museum, Gift of Frank L. Babbott

Prendergast considered his small body of still life painting an important part of his oeuvre. His Post-Impressionist style contrasted sharply with the more realistic approach of The Eight. He was one of the first American artists to recognize the importance of Cézanne, whom he knew personally. Working in a methodical manner, Prendergast evolved a style that was the only original contribution of American Impressionism. Prendergast's position in art is subsequent to American Impressionism just as Paul Signac's position belongs in French Post-Impressionism. And unlike earlier American Impressionists, who preferred oils, Prendergast was technically adept in both oil and watercolor.

In 1912 the artist and his younger brother moved to a studio just above that of William Glackens. His paintings from this period are tapestries and mythological scenes with women, swans, sailboats, flowers, nymphs, and horses—all relating to the earlier allegorical tradition of Puvis de Chavannes. Reference to flowers is found in a letter to his friend, Mrs. Esther Williams. A portion of this letter is recorded in Eleanor Green's *Maurice Prendergast, Art of Impulse and Color*, 1976:

> I haven't forgotten those wonderful flowers you showed us on Christmas morning. I am gradually coming around to flowers and you knocked into my head that morning that something great can be painted from them.

Prendergast's abbreviated style of depicting his subjects is unique to American painters. The still life and flower paintings were begun around 1910, and infuse the subjects with new spirit and style.

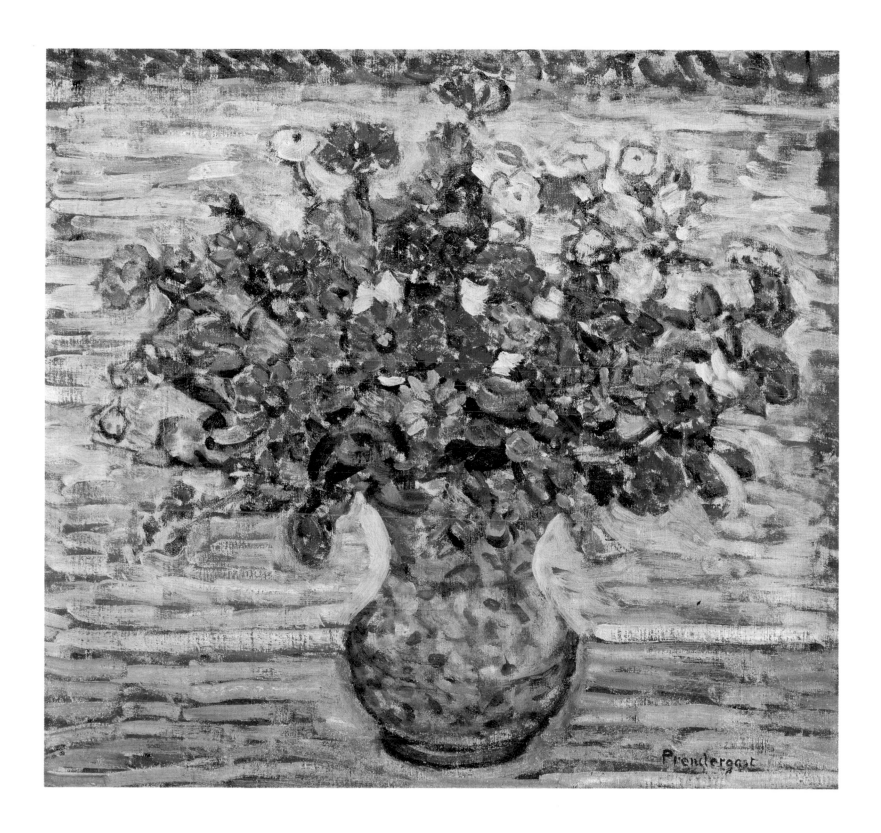

PLATE 20

Winslow Homer (1836–1910)

FLOWER GARDEN AND BUNGALOW, BERMUDA, 1899
Pencil and watercolor, 13⅝ × 20½ in. (34.6 × 52.1 cm)
The Metropolitan Museum of Art, Amelia B. Lazarus Fund, 1910. Copyright 1980 by
The Metropolitan Museum of Art

In the later years of his life Winslow Homer became recognized as the premier American genre painter, an estimation still held today. Homer's depictions of life in the 1860s, '70s, and '80s are among the most authentic and beautiful visual records of America in the 19th century. Although fundamentally self-taught, from the outset Homer demonstrated a mastery of observation and draftsmanship that is the mark of artistic genius. His work sets a distinct style, not relating to any previous school or tradition. The development of his use of line, however, must be credited to his apprenticeship with Boston lithographer J. H. Bufford.

Homer for the most part ignored flowers as a painting subject, using them only as accessories if needed. This is surprising, considering that his mother, Henrietta Maria Benson Homer, depicted primarily flowers and nature in her watercolors. *Flower Garden and Bungalow, Bermuda* is as close as Homer ever came to the painting tradition preferred by his mother. In Bermuda, where Homer summered, his happy state of mind seems to have produced the rapturous color. When once asked if nature was everywhere beautiful, waiting to be transformed by the artist, he replied, "Yes, but the rare thing is to find a painter who knows a good thing when he sees it. You must wait . . . patiently, until the exceptional, the wonderful effect or aspect comes." With *Flower Garden and Bungalow, Bermuda*, Homer recognized the exceptional and seized the moment.

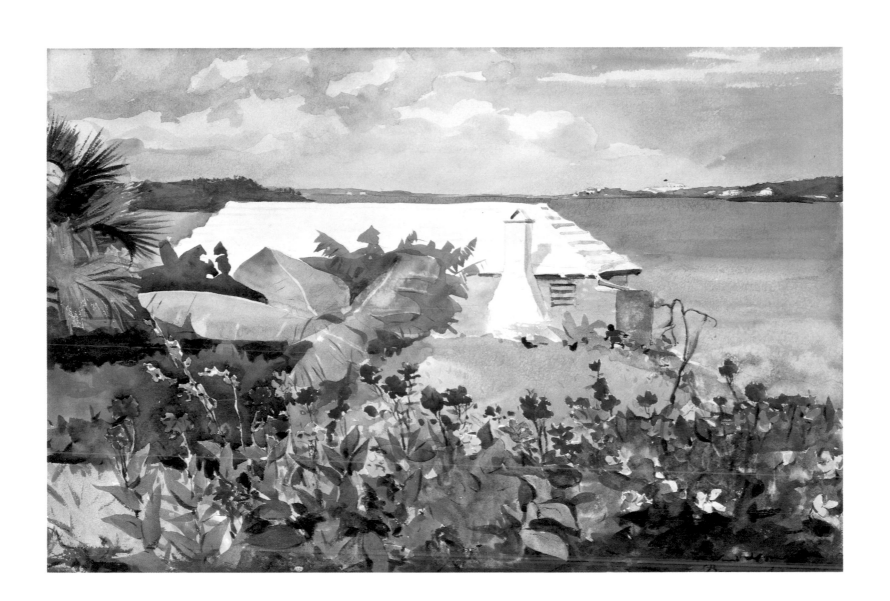

PLATE 21

Joseph Stella (1880–1946)

RED FLOWER, 1929
Oil on canvas, 57½ × 38½ in. (146.1 × 97.8 cm)
Collection of Sergio Stella

The Armory Show of 1913 had a profound effect on Joseph Stella. Stella's early work, largely figurative, owes a great deal to Old Master paintings at the Metropolitan Museum of Art in New York, as well as to his Italian academic training before he arrived in New York in 1896. In 1911 he went to Paris, where he became influenced by the work of the French modernists. Two years later he returned to enter his still lifes in the Armory Show. After this time his forms began to appear fractured and broken. In a unique way he combined what he had seen in Paris with his interest in Gino Severini, Robert Delaunay, Jacques Villon, and Francis Picabia. Often he would break away from these styles; the independence enabled him to create some of his finest works. His two main themes for depiction were industrialized, geometric bridges, and curvilinear, biomorphic plants—and though the subjects differ he painted both in a stylized, symmetrical manner.

In 1922 Stella traveled throughout Italy—to Naples, Pompeii, Herculaneum, Paestum, and Capri. He returned to New York, then traveled to Europe again in 1926 and lived there for eight years. He made several safaris to North Africa in 1926 and 1929, from which came his series of extraordinary jungle fantasies that are the masterworks of his later career. These exotic works are rife with religious and sexual symbolism. Precedence for Stella's jungle paintings can be found in the work of Henri Rousseau, whose *The Dream* (Museum of Modern Art, New York) was shown in an exhibition at Alfred Stieglitz's 291 Gallery in 1910, and was probably seen by Stella then.

Red Flower is certainly Stella's masterpiece of the jungle paintings. The symmetrical bisection of the canvas by the flower and stem gives the blossom a totem-like effect. The tree limbs behind the flower are perhaps symbolic of legs, giving the blossom its intended sexual meaning. The flat patterning of leaves on either side of the tree limbs limits the depth of the painting and forces one's focus onto the main image. The two birds continue the exotic tropical motif. They stand in heraldic posture, as if in the rite of worship—or given Stella's interest in music, they recall the *Rite of Spring*.

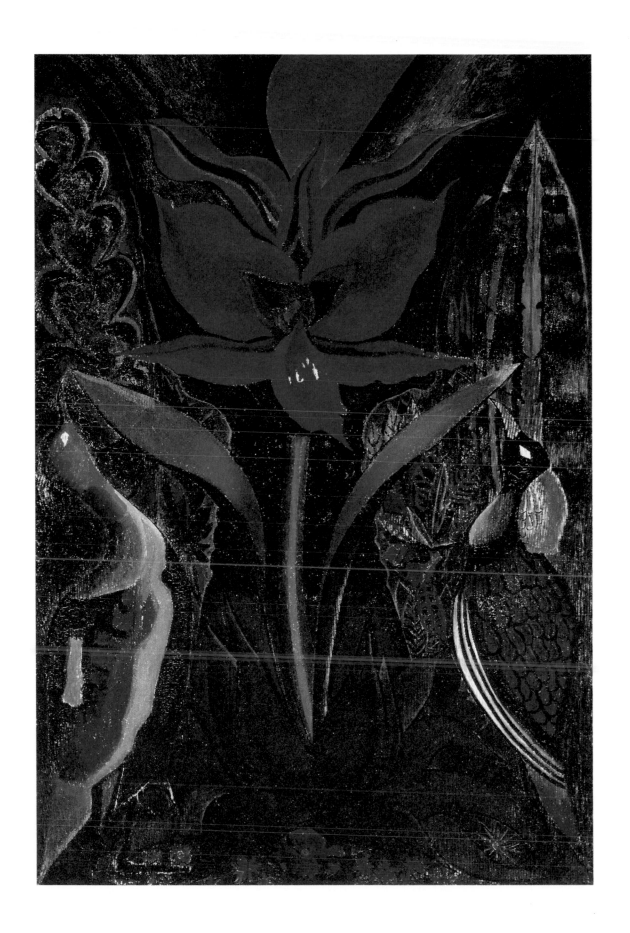

PLATE 22

Georgia O'Keeffe (1887–)

RED FLOWER, 1919
Oil on canvas, 17 × 22 in. (43.2 × 55.9 cm)
Collection of Dr. and Mrs. Thomas Stokes

While a member of the Stieglitz circle, the group of American artists and photographers based at 291 Fifth Avenue in the early decades of the 1900s, Georgia O'Keeffe came into contact with Charles Demuth's clean, crisp surfaces, Charles Sheeler's sterilized volumes, and Paul Strand's close-up photographic studies. All of these qualities were synthesized in O'Keeffe's vision. Although no theoretical framework underlies O'Keeffe's work, her paintings do incorporate her responses to scientific photography, the airplane, and the microscope. After teaching in Texas, Virginia, and South Carolina, O'Keeffe moved to New York in 1918. Stieglitz arranged exhibitions of her work at the 291 Gallery, the Intimate Gallery, and later at An American Place, all small avant-garde galleries which he established in New York.

She spent her first summer in New Mexico in 1929 and moved there permanently in 1946 after Stieglitz's death. During these years in New Mexico her paintings have explored the terrain of the southwestern desert—its mountains, canyons, vast spaces, vegetation, and the debris of rocks and sun-bleached animal bones.

Her flower paintings, begun in the late teens, are recognized today as among her masterpieces. In these works the viewer is taken into the center of the flower. This close-up focus results in an image that is both symbolic and abstract. The magnification of the flower creates an intensity of color, a lushness of surface, and a delicacy of texture that is unsurpassed in vision and in technique.

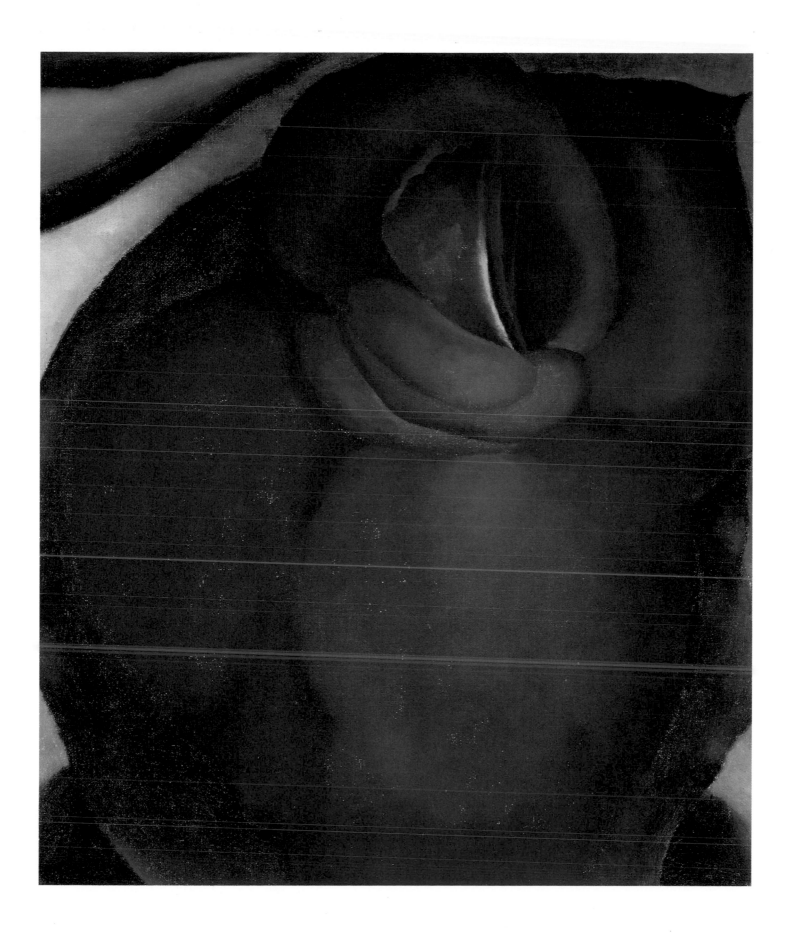

PLATE 23

Georgia O'Keeffe (1887–)

RED POPPY, 1927
Oil on canvas, 7 × 9 in. (17.8 × 22.9 cm)
Private collection. © Sotheby Parke-Bernet. Agent: Editorial Photocolor Archives

In an exhibition catalogue for An American Place, 1939, O'Keeffe writes:

A flower is relatively small. Everyone has many associations with a flower—the idea of flowers. You put out your hand to touch the flower—lean forward to smell it—maybe touch it with your lips almost without thinking—or give it to someone to please them. Still—in a way—nobody sees a flower—really—it is so small—we haven't time—and to see takes time, like to have a friend takes time. If I could paint the flower exactly as I see it no one would see what I see because I would paint it small like the flower is small.

So I said to myself—I'll paint what I see—what the flower is to me but I'll paint it big and they will be surprised into taking time to look at it—I will make even busy New Yorkers take time to see what I see of flowers.

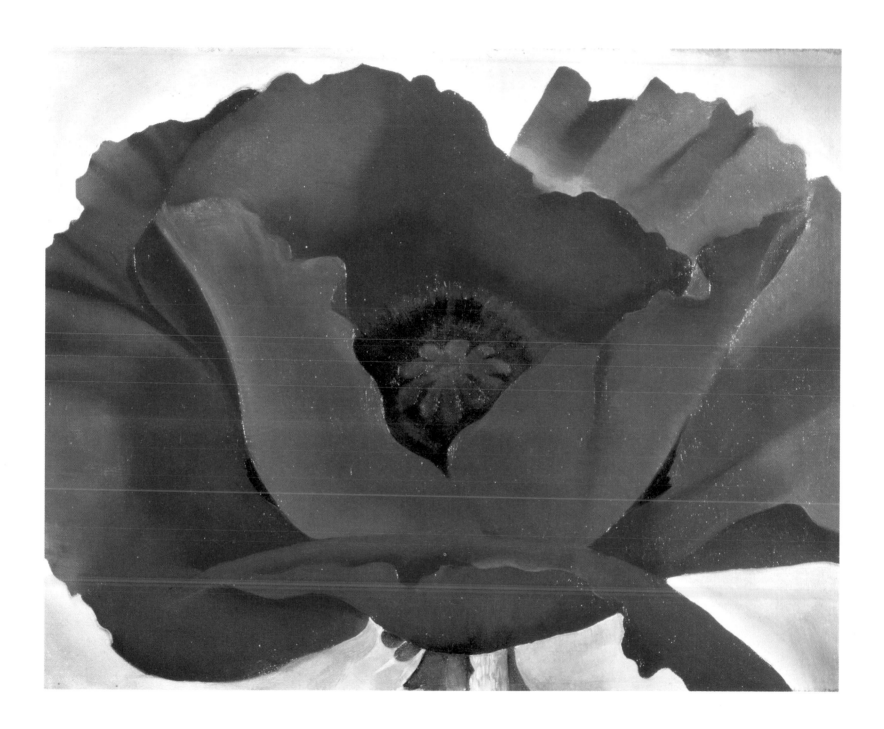

PLATE 24

Charles Demuth (1883–1935)

AMARYLLIS
Watercolor, 17½ × 11¾ in. (44.5 × 29.9 cm)
The Cleveland Museum of Art, Hinman B. Hurlbut Collection

Only a few first-rate American artists can properly be called flower painters, and Charles Demuth is one. From his earliest known work, painted around 1895, until the year before his death, flowers were a major influence in his art.

Shortly after Demuth sustained a crippling hip injury at the age of four, his family moved to Lancaster, Pennsylvania. There the Demuth garden, which was tended mainly by his mother, became quite famous. As Dr. Alvord Eiseman, an historian specializing in the work of Charles Demuth, points out, the garden was extremely private, and its beauty appealed to Charles as a young boy and throughout his life. It was also an inspiration to the other members of his artistic family: his grandmother Caroline and aunt Louise, who were both amateur flower painters, and his father, who was an amateur photographer.

In Lancaster, Charles was given tutoring in art by a Miss Purple and a Miss Bowman. Among the arts they taught him was that of china painting. Charles painted mainly flowers and took great delight in their form and color. One cannot be sure whether he took as strong an interest in gardening as his mother did, but she brought him the finest gladioli, calla lilies, and other cut flowers that could be found in the two public markets in Lancaster.

Demuth's early watercolors were dextrous exercises, combining the freedom of color of the Expressionists and the analysis of form of the Cubists. He was influenced by his friends John Marin, Alfred Maurer, Max Weber, and Arthur Dove, as well as by the work of Matisse, the Fauves, and Cézanne. From the French modernist movement, Demuth derived the synthesis of form and motion and the delicacy of color with which he chose to depict his flowers.

In 1938, Henry McBride commented on the flower works of Charles Demuth: "I rank them among the most memorable drawings to have been produced anywhere in this modern period." Like Demuth's other interest, that of precision in architecture, flowers were for him the most perfect of structures.

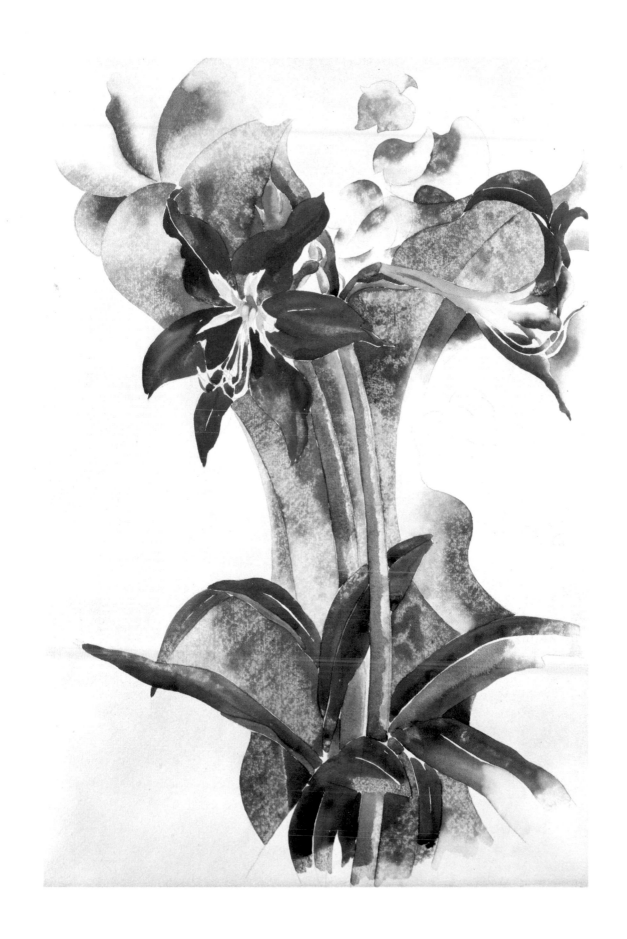

PLATE 25

Ernest Lawson (1873–1939)

GARDEN LANDSCAPE
Oil on canvas, 20⅛ × 24 in. (51.1 × 61 cm)
The Brooklyn Museum, Bequest of Laura L. Barnes

Lawson's finest works are the snowy winter scenes that he painted in the High Bridge–Washington Heights area of Manhattan. He moved to this part of New York from North Carolina in 1898, and remained there eight years. During that time he became a member of The Eight, and exhibited with them at the Macbeth Gallery in 1908.

Lawson first arrived in New York in 1891 to study at the Art Students League, and perhaps by chance, his teacher was to be John Twachtman. The next year he enrolled in the art school formed by Twachtman and J. Alden Weir, and was introduced to the Impressionist style. In 1893 Lawson made his first visit to France, enrolling at the Académie Julian. He later traveled through the south of France and to Moret-Sur-Loing, outside Paris, where he met Alfred Sisley. Lawson must have heard about, or even visited, Giverny, which Monet had purchased in 1890.

Garden Landscape quite closely resembles the early Giverny paintings of Monet. Lawson's paintings of flowers are few, but his use of color and form in this painting, for example, is reminiscent of a late-, almost post-, Impressionist style. Although his work is often identified with the Impressionist movement, due to the scattered application of paint in his misty snow scenes and in *Garden Landscape*, it diverged from the soft, hazy style of his Impressionist teachers. Lawson's use of strong diagonals, and his jutting shapes and masses, ally him to more contemporary European styles with which he was familiar. Here, by using flowers as adjuncts to the landscape, Lawson makes this painting one of his most beautiful.

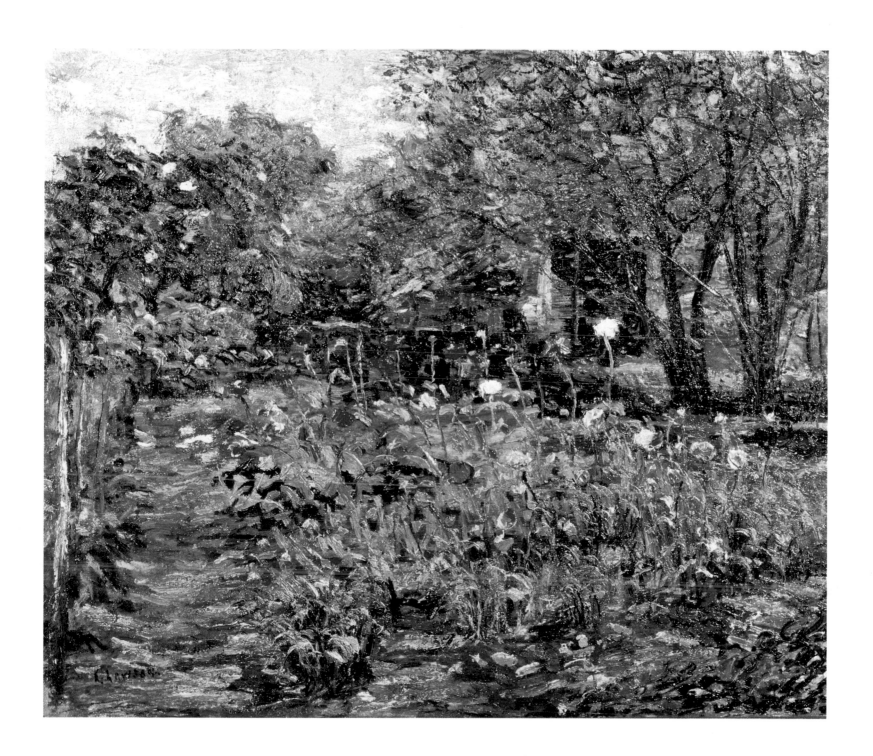

PLATE 26

Charles Sheeler (1863–1965)

GERANIUM, c. 1926
Oil canvas, 32 × 26 in. (81.3 × 66 cm)
Collection of the Whitney Museum of American Art

We associate the work of Charles Sheeler with the term Precisionism; his work is typified by a purity and hard-edged line that may have originated with his interest in photography and drafting. Sheeler was raised in Bucks County, Pennsylvania, where he first saw Shaker furniture which later became an influence in his art.

Sheeler made several trips to Europe between 1890 and 1902. Like other young artists in Paris at the beginning of this century, he was eager to apply the formal influences of European modernists such as Picasso, Braque, Matisse, and Derain, but did not wholly embrace their stylistic principles. He wanted not to take the European schools and transplant them in America, but to distill his own style from them. Eight years after his return, Sheeler's mature stylistic identity emerged, a style incorporating native American subjects—the rural and industrial themes for which he is known—with the modernist movement begun in Europe. He simplified Cubism, giving it a more appealing form.

Sheeler's earliest works are floral still lifes, and his concern for this genre of painting continued throughout his life. The motion and animation intrinsic in the unfolding leaves and radiating petals of flowers seem to have greatly interested him. *Geranium* exemplifies Sheeler's brilliant and unique intermingling of different elements. The abstracted, simplified Shaker chair and the placement of the geranium in the delicately balanced space must have fulfilled Sheeler's stated desire to create a painting which was American in character.

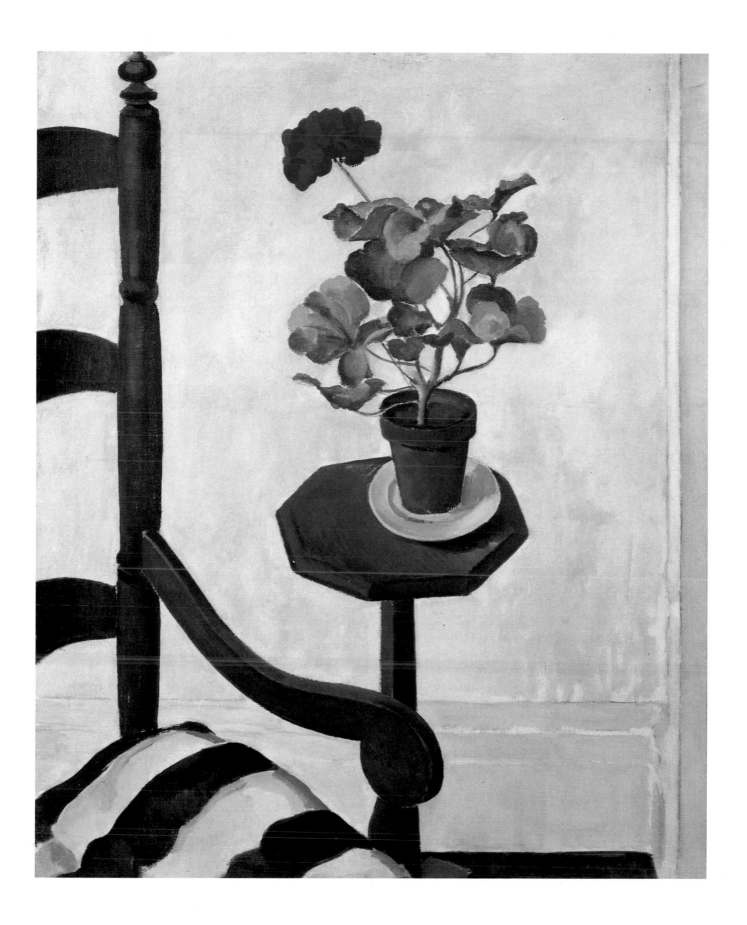

PLATE 27

Arthur Dove (1880–1946)

HUNTINGTON HARBOR, 1929
Mixed media, 13¼ × 19¼ in. (33.6 × 48.8 cm)
Hirshhorn Museum and Sculpture Garden, Smithsonian Institution

Arthur Dove only made one sojourn abroad, in 1908, and it was on that trip that he came to experience the revolutionary energies of Fauvism and Cubism, which were to be the stimuli for his own abstract paintings. Upon his return, he was invited by Alfred Stieglitz to exhibit in his "Younger American Painters Show" of March, 1910.

With John Marin and Georgia O'Keeffe, Dove was among the most notable proponents of American modernism in the first decades of this century. His importance in the development of American modernism is due to his early and extreme expression of non-representational imagery. Before World War I, Dove was considered the most radical American painter.

Dove began to make his collages/assemblages in 1924 and continued with these through 1930. He lived on the 42-foot yawl *Mona*, and because of the cramped working conditions, his assemblages were small. Life on the boat was difficult, and being destitute, Dove made the assemblages from found objects. The materials, coupled with Dove's special selection and arrangement, can be viewed on three levels: the literal—where the objects have their assigned meaning in nature; the formal or visual—where the textures, colors, and composition of the objects have importance; and finally the psychic level—where one inquires as to the meaning and relationships of the objects in their new context. *Huntington Harbor* is one of the most realistic assemblages done during this period. Although the scene is recognizable, the esthetic statement formed by the found objects is non-objective, surreal, and unique in its time.

PLATE 28

William Glackens (1870–1938)

BOUQUET AGAINST YELLOW WALLPAPER
Oil on canvas, 18 × 15 in. (45.7 × 38.1 cm)
Private collection. Courtesy of Kraushaar Galleries, New York

The exhibition of The Eight at the Macbeth Gallery in 1908 included six major works by Glackens. All six works show a dark and somber palette—evidence of Glackens' interest in the works of Edouard Manet, which he had seen while abroad in the 1890s. After the Macbeth Gallery exhibition his paintings began to resemble those of Renoir. It was during his many trips to France that Glackens absorbed the character of contemporary French painting for his own work. Undeterred by criticism that his work was imitative, Glackens persisted in this style. The catholicity of his taste was demonstrated when he was sent to Paris in 1912 to buy paintings for Albert C. Barnes. He returned with a diverse group of works by important artists such as Cézanne, Renoir, Manet, Degas, Gauguin, Van Gogh, and Matisse. These paintings form the nucleus of the Barnes Collection in Merion, Pennsylvania.

Glackens was not an active participant in the formation of The Eight. Unlike Robert Henri and John Sloan, he was a quiet man, but he had a highly developed sense of humor. A fisherman, a gourmet, a gardener—he relished the quiet, contemplative pursuits with which peace of mind is cultivated. Glackens often used flowers as his subjects; he enjoyed the relaxation of painting them. It is interesting that exhibitions of Glackens' flower paintings drew suggestions from garden club ladies that his vases were too small to provide water for the blossoms. However, in 1936 he won the Allegheny County Garden Club Prize at the Carnegie International in Pittsburgh, so one can assume he was able to make the vases big enough by then! In his recorded acceptance speech for the awards, which was broadcast on station WJZ, New York, Glackens acknowledged the debt nearly every artist owes to the flower: "In nature nothing is more expressive, nothing more irresistible."

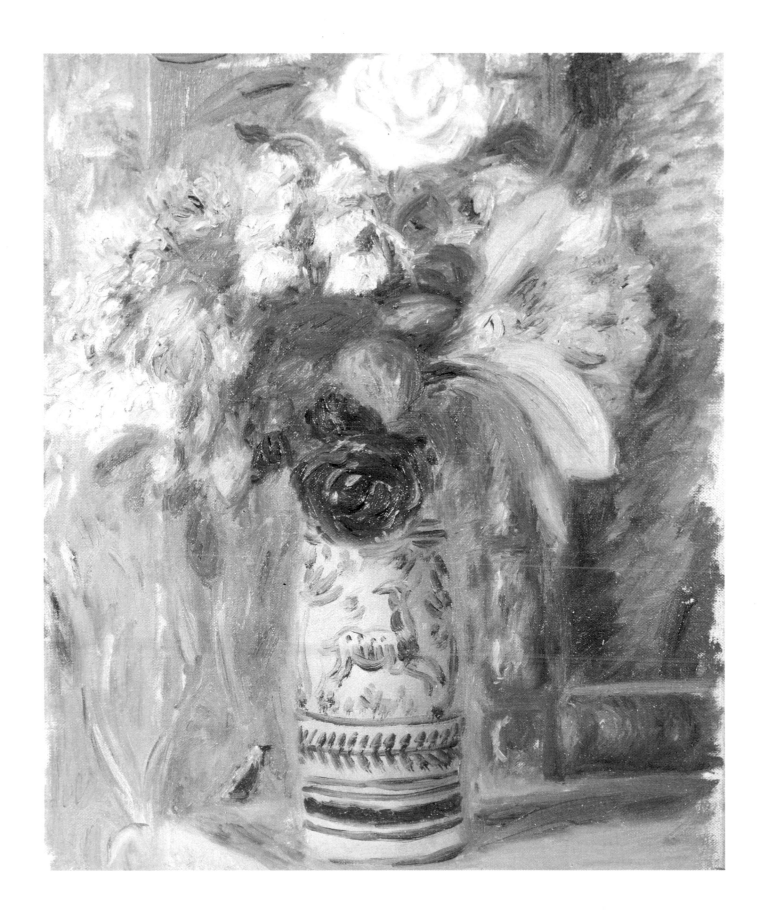

PLATE 29

Horace Pippin (1888–1946)

SPRING FLOWERS WITH LACE DOILY, 1941
Oil on panel, 14 × 10 in. (35.6 × 25.4 cm)
Collection of R.S. Schafler

That the naive tradition of painting continued into the 20th century is not altogether surprising. The interest in Jung's studies of psychology and "automatic writing," and the desire of the Surrealists and Abstract Expressionists of the 1940s and '50s to return to an uninhibited, childlike state of perception enticed other painters to follow. The artist who sought the unsophisticated, subconscious state was in a sense turning away from the world's madness. French modernists like Picasso were inspired by exhibitions of African sculpture. Matisse, in his later works, sought a simple flatness of form.

The abstract forms of American naive art influenced not only the work of Americans, but also that of European artists who were able to see exhibitions of such work in Paris during the late 1940s. Recognition of the role this early art has played in American painting was given in the 1974 exhibition of American Folk Art at the Whitney Museum of American Art in New York, where many of the objects displayed came from artist/collectors like Eli Nadelman.

Pippin, one of the most respected black naive painters in America, was born in West Chester, Pennsylvania, to parents who were freed slaves. During his service in World War I, he was wounded and lost the use of his right arm. When he returned home he faced the difficult task of rehabilitation. He began to paint. Almost from the beginning his work was met with enthusiasm, attracting the attention of art world luminaries such as N.C. Wyeth, Albert Barnes, and Holger Cahill. In 1920 Pippin married, and his wife was interested in tending a beautiful flower garden. Horace enjoyed watching the buds come to blossom.

Had Pippin received artistic training he might not have painted flowers. But fortunately for us, flowers, which are an important part of the naive tradition, were an inspiration to him. Pippin was a master of abstract composition, color, and accommodation to the flatness of the picture plane. The patterning of the flowers and the contrasting doily bespeak Pippin's subtle sensitivity to the unity of his painting.

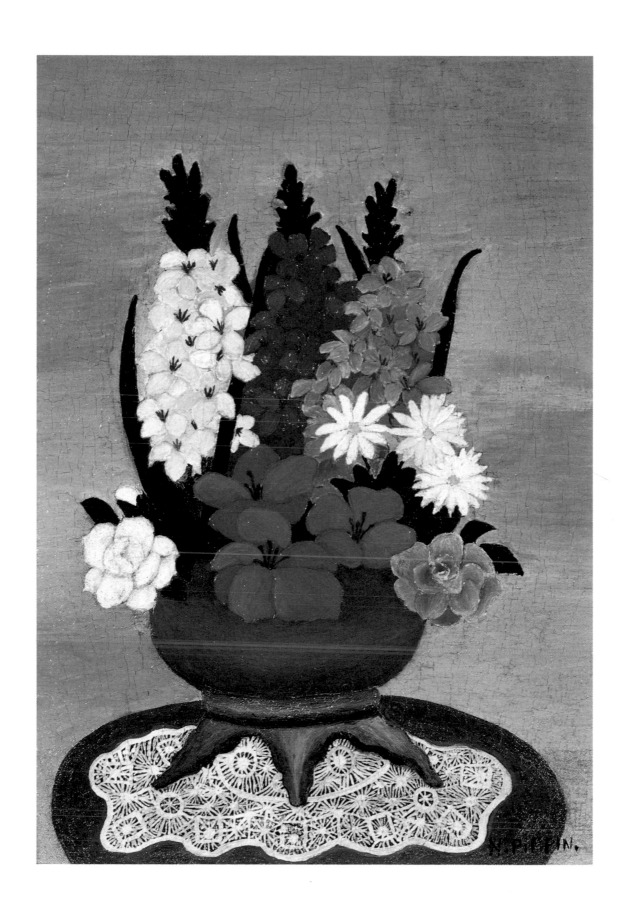

PLATE 30

Marsden Hartley (1877–1943)

WILD ROSES, 1942
Oil on Masonite®, 22 × 28 in. (55.9 × 71.1 cm)
The Phillips Collection, Washington, D.C.

Marsden Hartley's life was filled with contradiction and discord. As an artist he was torn between the refined European tradition and the development of an American style reflecting the country's pioneering, adventuresome heritage. His life was fraught with paradoxical impulses: the desire for solitude and the need for companionship; his need both to paint and to write poetry; and the clash between his sophisticated sensibilities and his humble origins.

He moved to New York around 1898, after studying at the Cleveland School of Art, and undertook studies at the Chase School with F. Louis Mora, F. V. Du Mond, and William Merritt Chase. His first exhibition in 1909 at Alfred Stieglitz's Photo-Seccession Gallery ("291") was of landscapes influenced by Albert Pinkham Ryder. In 1912 Hartley traveled to Europe for the first time. In Paris he experimented briefly with Cubism and non-objective compositions. During this time he also exhibited in Munich with the German Expressionist Blue Rider Group, at the invitation of Franz Marc. In 1913 he returned to New York to exhibit at the to-be-momentous Armory Show.

Like other American painters Hartley learned a good deal from Cézanne, whose focus on still life enabled them to retain an association with the observed world while experimenting with new concepts on the very nature of art. Thus, while the still life had been relegated to a "middle class" appeal among painters, it had become important for them again by 1920. Flowers, which evaded the Cézanne still life, are given Cubist form in Hartley's *Wild Roses*.

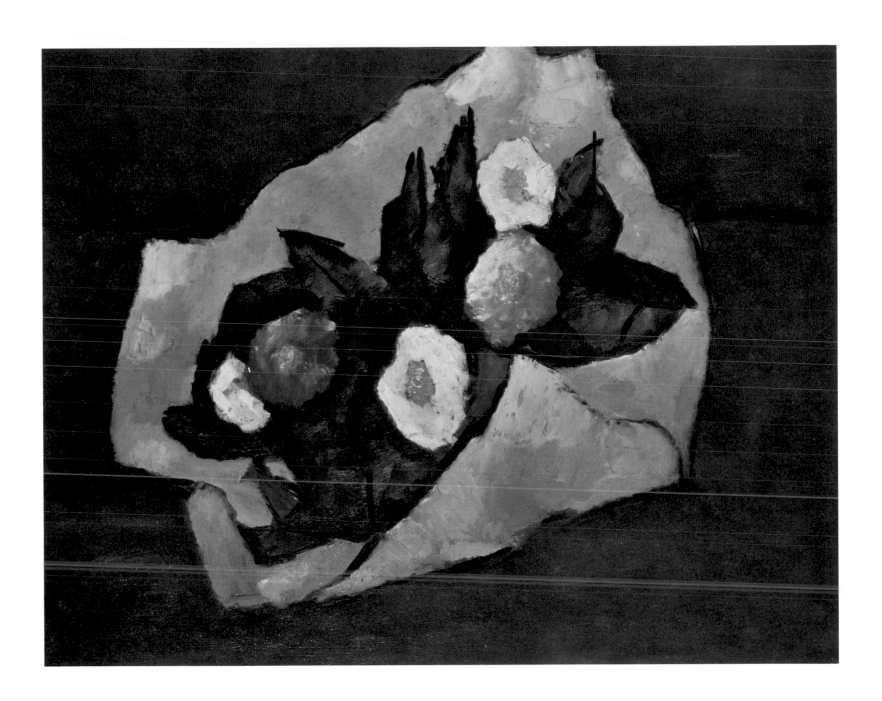

PLATE 31

Morris Louis (1912–1962)

FLORAL, 1959
Acrylic on canvas, 8 ft. 5 in. × 11 ft. 10 in. (2.57 × 3.60 m)
Collection of Irwin and Bethea Green

Morris Louis was the leader of the movement we now call Washington Color Field painting. Under the influence of art critic Clement Greenberg, Louis and fellow artist Kenneth Noland visited Helen Frankenthaler in New York, and there encountered her *Mountain and Sea*, one of the first semi-abstract paintings being done at the time, which introduced a technique of staining the canvas with paint rather than applying it to the surface with a brush. As Louis described it, they recognized this work as a bridge "between [Jackson] Pollack and what was possible."

Louis' early paintings, which are called *Veils*, are large expanses of unprimed canvas on which he has poured acrylic paint. He painted *Veils* until 1959, when he embarked on a series of paintings called *Florals*, of which this is one. Unlike the dark overall coloring in the *Veils* series, the paintings belonging to *Florals* emphasize their color configurations, making the colors conspicuous as discrete entities, as specific shapes. The *Veils* generally hang from top to bottom; the *Florals* radiate from, or converge to, the center, like petals.

The work of Louis represents a metamorphosis of the floral tradition. The intense color which had previously concerned 19th-century flower painters became a central issue for the late 1950s and '60s. Then paintings were supposed to be exclusively about color, and the principal natural source of color was the flower. The Color Field painters also professed an "honesty to the material." How sincere is the artist who makes canvas appear to be glass or a vase of flowers? Is that deception? Is deception acceptable? Even though narrative subject matter was rejected, and physical material (pigment, canvas, and their literal qualities) became the subject, painting still related to floral concepts. In addition to employing the color of flowers, these works feature the use of canvas without surface varnish, exposed to the elements—making an analogy to the fragility of flower petals.

PLATE 32

Charles Burchfield (1893–1967)

DANDELION SEED HEADS AND THE MOON, 1961–65
Watercolor, 54¼ × 38½ in. (137.8 × 97.8 cm)
Courtesy of Kennedy Galleries Inc., New York

Charles Burchfield's watercolors of 1916–20 most strongly expressed his romanticism. It was to this early period in his development that he would return later in life. The paintings take the form of childlike fantasies—visual counterparts of such contemporary American literature as the works of Sherwood Anderson: a glorification of the free spirit of childhood experienced in small American towns, similar to Burchfield's hometown of Salem, Ohio. Burchfield's works are concerned with expression of the mystery and terror of dreams and fantasies.

Technically, his watercolors are some of the finest in American art. In comparison, his relatively few essays in oil are stiff and clumsy. Watercolor as Burchfield uses it has an Oriental quality, and he may have been influenced by examples of Oriental watercolors and prints available to him at the Cleveland Art Museum. Burchfield's translation of invisible forces into a pictorial image in such works as *Dandelion Seed Heads and the Moon* relates his vision to that of the German Expressionist Edvard Munch.

It is in Burchfield's later works that his earlier ideas are crystallized. Although he began many new paintings after 1943, Burchfield often preferred to rework older ones, refining and enlarging them; he often pieced newer paper to older surfaces, all the while carefully matching the new colors to the older ones. Here Burchfield is at his best as he paints nature's pulsing vitality, and records the motion of growth in a revolutionary, animated style.

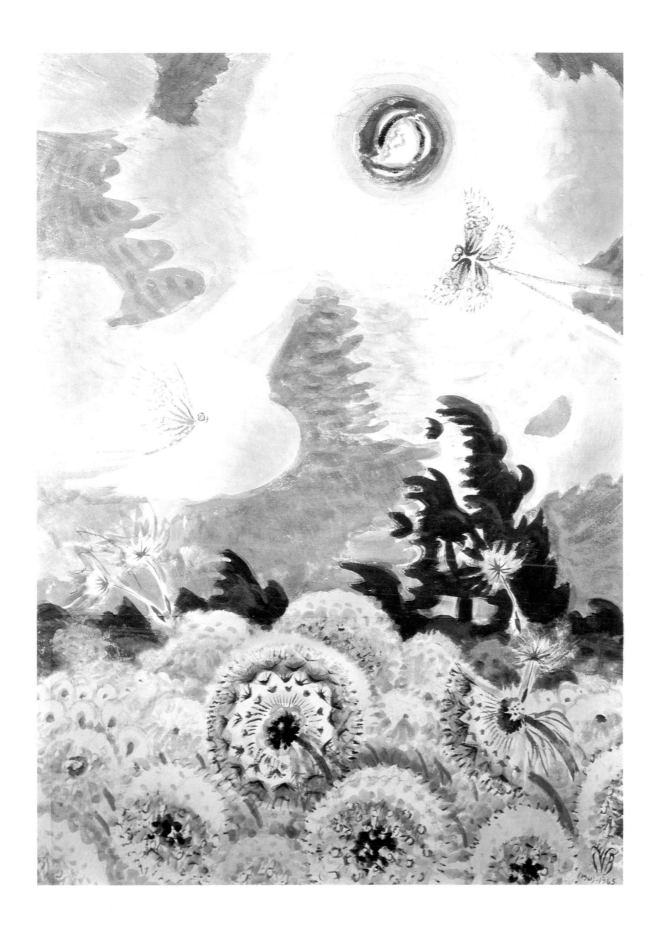

Selected Bibliography

BOOKS

Audubon, John James. *Birds of America*. Introduction and descriptive text by William Vogt. New York: Macmillan, 1939.

Bermingham, Peter. *Jasper F. Cropsey (1823-1900): A Retrospective View of America's Painter of Autumn*. College Park: University of Maryland Press, 1968.

Besuning, Margaret. *Mary Cassatt*. New York: Hyperion Press, 1944.

Boyle, Richard J. *American Impressionism*. Boston: New York Graphic Society, Ltd., 1974.

Breeskin, Adelyn Dohme. *Mary Cassatt: A Catalogue Raisonné of the Oils, Pastels, Watercolors, and Drawings*. Washington D.C.: Smithsonian Institution Press, 1970.

Brown, Milton W. *The Modern Spirit: American Painting 1908-1935*. London: Hayward Gallery, 1977.

Bullard, Edgar John. *Mary Cassatt: Oils and Pastels*. New York: Watson-Guptill Publications, 1972.

Cahill, Holger. *Max Weber*. New York: The Downtown Gallery, 1930.

Catalogue of the Memorial Exhibition of the Works of the Late John Singer Sargent. Boston: Museum of Fine Arts, 1925.

Chwast, Seymour, and Chewings, Emily Blair. *The Illustrated Flower*. New York: Push Pin Press, 1977.

Cortissoz, Royal. *John LaFarge: A Memoir and a Study*. New York: Kennedy Graphics, 1971.

The Development of Floral Painting from the 17th Century to the Present. Special Loan Exhibit. Saint Louis: Saint Louis City Art Museum, 1937 (May).

Downes, William Howe. *Life and Works of Winslow Homer*. Boston: Houghton Mifflin, 1911.

———. *John Sargent: His Life and Work*. London: Thornton Butterworth, Ltd., 1926.

DuBois, Guy Pène. *Edward Hopper*. New York: Whitney Museum of American Art, 1931.

———. *William J. Glackens*. New York: Whitney Museum of American Art, 1931.

Flexner, James Thomas. *The World of Winslow Homer, 1836-1910*. New York: Time Inc., 1966.

Flowering of American Folk Art. Exhibition Catalogue. New York: Whitney Museum of American Art, 1974.

Frank W. Benson, Edmond C. Tarbell. Exhibition of Paintings, Drawings, and Prints. Boston: Museum of Fine Arts, 1938.

Frankenstein, Alfred Victor. *William Sidney Mount*. New York: Harry N. Abrams, 1975.

Freeman, Richard B. *Niles Spencer*. Lexington: University of Kentucky, 1965.

Friedman, Martin; Hayes, Bartlet H.; and Millaro, Charles. *Charles Sheeler*. Washington D.C.: Smithsonian Institution Press, 1968.

Gallatin, Albert Eugene. *American Water-colorists*. New York: E.P. Dutton, 1922.

Gerdts, William H., and Burke, Russell. *American Still Life Painting*. New York: Praeger Publishers, 1971.

Gibson, Frank. *The Art of Henri Fantin-Latour: His Life and Work*. London: Drane's Ltd., 1924.

Glackens, Ira. *William Glackens and the Ashcan Group*. New York: Crown Publishers, 1957.

Goodrich, Lloyd. *Winslow Homer*. New York: Macmillan Co., for the Whitney Museum of American Art, 1944.

———. *Edward Hopper*. New York: Whitney Museum of American Art, 1949.

———. *Edward Hopper*. Exhibition Catalogue. New York: Whitney Museum of American Art, 1964.

———. *Edward Hopper: Selections From the Hopper Bequest to The Whitney Museum of American Art*. Exhibition Catalogue. New York: Whitney Museum of American Art, 1971.

———. *Georgia O'Keeffe*. New York: Whitney Museum of American Art, 1970.

———. *Albert P. Ryder*. New York: George Braziller, 1959.

Goosens, E.C. *Stuart Davis*. New York: George Braziller, 1959.

Haskell, Barbara. *Arthur Dove*. Boston: New York Graphic Society, Ltd., 1974.

Hendricks, Gordon. *The Life and Works of Thomas Eakins*. New York: Grossman, 1974.

Holden, Donald. *Whistler Landscapes and Seascapes.* New York: Watson-Guptill Publications, 1969.

Hoopes, Donelson F. *Winslow Homer Watercolors.* New York: Watson-Guptill Publications, 1969.

Hopson Pittman: Retrospective Exhibition of His Works Since 1920. Raleigh: North Carolina Museum of Art, 1960.

Jaffe, Irma B. *Joseph Stella.* Cambridge: Harvard University Press, 1970.

Janson, H.W. *History of Art.* New York: Harry N. Abrams, 1962.

Jerome Myers, 1867-1940. Exhibition Catalogue. New York: Kraushaar Galleries, 1970 (April 13–May 2).

Lawall, David B. *Asher B. Durand: A Documentary Catalogue of the Narrative and Landscape Paintings.* New York: Garland, 1978.

McCoubrey, John. *American Art, 1700-1960: Sources and Documents.* Englewood Cliffs, N.J.: Prentice-Hall, 1965.

McCracken, Harold. *Portrait of the Old West.* New York: McGraw-Hill, 1952.

McLanathan, Richard. *The American Tradition in the Arts.* New York: Harcourt, Brace, and World, 1965.

Marin, John. *John Marin.* New York: Holt, Rinehart & Winston, 1970.

Mary Cassatt, 1844–1926. Exhibition Catalogue. Washington, D.C.: National Gallery of Art, 1970 (Sept. 27–Nov. 8).

Max Weber: Retrospective Exhibition. New York: Whitney Museum of American Art, 1949.

Memorial Exhibition of the Works of Julian Alden Weir. New York: The Metropolitan Museum of Art, 1924.

Mitchell, William J. *Ninety-Nine Drawings by Marsden Hartley (1877-1943).* From the Marsden Hartley Memorial Collection. Meriden, Conn.: Treat Gallery, Bates College, 1970.

Mount, Charles Merrill. *John Singer Sargent: A Biography.* New York: W.W. Norton & Co., 1955.

Myers, Jerome. *Artist in Manhattan.* New York: American Artists Group, 1940.

Nachman, Cynthia. *Say It with Flowers.* Hempstead, New York: The Emily Lowe Gallery, 1973.

National Collection of Fine Arts, Smithsonian Institution. *Fredrick Edwin Church.* New York: M. Knoedler & Co., 1966.

Novak, Barbara. *American Painting of the 19th Century.* New York: Praeger Publishers, 1969.

The Phillips Publications, Number One. *Julian Alden Weir, An Appreciation of His Life and Works.* New York: E.P. Dutton, 1922.

Prideau, Tom. *The World of Whistler, 1834–1905.* New York: Time-Life Books, 1970.

Prown, Jules David. *John Singleton Copley.* Cambridge: Harvard University Press, 1966.

Ralph Albert Blakelock, 1847–1919. Lincoln: University of Nebraska, 1975 (Jan. 4–Feb. 9).

Reich, Sheldon. *John Marin, A Stylistic Analysis and Catalogue Raisonné.* Tucson: Tucson University Press, 1970.

Rhys, Hedley Howell. *Maurice Prendergast, 1859–1924.* Cambridge: Harvard University Press, 1960.

Ritchie, Andrew Carnegie. *Charles Demuth.* New York: The Museum of Modern Art, 1950.

Robacher, Earl F. *Touch of the Dutchland.* New York: A.S. Barnes & Co., 1965.

Rodman, Seldon, and Cleaver, Carol. *Horace Pippin.* Garden City: Doubleday & Co., 1972.

Rourke, Constance, and Sheeler, Charles. *Artist in The American Tradition.* New York: Harcourt, Brace & Co., 1938.

Rugoff, Milton, ed. *The Britannica Encyclopedia of American Art.* New York: Simon and Schuster, 1973.

Spalding, Frances. *Whistler.* London: Phaidon Press, Ltd., 1979.

Stebbins, Theodore E., Jr. *American Light.* Exhibition Catalogue. Washington, D.C.: National Gallery of Art, 1980.

———. *American Master Drawings and Watercolors: A History of Works on Paper from Colonial Times to the Present.* New York: Harper & Row, 1976.

———. *The Life and Works of Martin Johnson Heade.* New Haven: Yale University Press, 1975.

Stuart Davis. Paris: Musée d'Art Moderne de la Ville de Paris, 1966.

Stuart Davis Memorial Exhibition 1894–1964. Washington, D.C.: National Collection of Fine Arts, Smithsonian Institution, 1965.

Talbot, William S. *Jasper F. Cropsey, 1823–1900.* New York: Garland Publishing, 1977.

Three American Masters of Watercolor: Marin, Demuth, Pascin. A loan exhibition from the Fernand Howald Collection, The Columbus Gallery of Art. Cincinnati: Cincinnati Art Museum, 1965 (Feb.–Mar.).

University of California at Santa Barbara, the Art Galleries. *Charles Demuth: The Mechanical Encrusted on the Living.* Goleta, Calif.: Triple R Press, 1971.

Wattenmaker, Richard J. *The Art of Charles Prendergast.* New Brunswick: Rutgers University Art Gallery, 1968. (Distributed by New York Graphic Society, Ltd.)

William Glackens in Retrospect. Saint Louis: Saint Louis City Art Museum, 1966.

Wilmerding, John. *The Genius of American Painting.* New York: William Morrow and Co., 1973.

A World of Flowers: Paintings and Prints. Philadelphia: Philadelphia Museum of Art, 1963 (May 2–June 9).

Young, Mahonri Sharp. *Early American Moderns: Painters of the Stieglitz Group.* New York: Watson-Guptill Publications, 1974.

ARTICLES

Baur, John I.H. "American Luminism: A Neglected Aspect of the Realist Movement in 19th Century American Painting." *Perspectives in U.S.A.* 9 (Autumn 1959).

Morrill, Edward. "Louis Prang, Lithographer." *Hobbies,* August 1940, pp. 30-33.

Perry, Lila Cabot. "Remembrances of Claude Monet." *The American Magazine,* March 1927.

Sellers, Charles Coleman. "Charles Willson Peale." *Transactions of the American Philosophical Society* 42 (1952).

Soria, Martin S. "Sanchez Cotan's Quince, Cabbage, Melon, and Cucumber." *Art Quarterly* VIII (1945), pp. 223-230.

Index

Italicized page numbers refer to illustrations.